LEGENDARY LOCALS

OF

JAMESTOWN

RHODE ISLAND

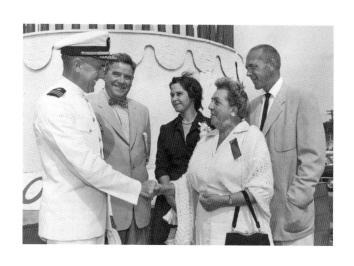

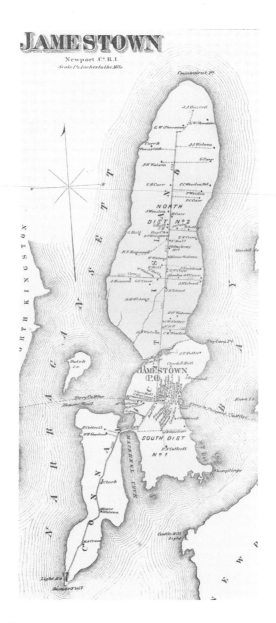

1870 Map of Jamestown

This map of Jamestown originally appeared in *Atlas of the State of Rhode Island and Providence Plantations*, which was compiled and published by D.G. Beers & Co. in 1870. A hand-colored copy of the map was presented to the Jamestown Historical Society by William W. Weeden in 1943. (Courtesy of the Jamestown Historical Society.)

Page 1: Marguerite Elliott Eddy

Marguerite Eddy (page 100), parade adjutant for Jamestown's tercentenary parade in 1957, accepts the congratulations of the unidentified US Navy representative to the celebration. With her in front of the 18-foot-high birthday cake donated by the Jamestown Arnold-Zweir Post 22 of the American Legion are, left to right, John L. Smith and Martha Greig (page 99), cochairs for the week-long celebration, and Jamestown Town Council president Dr. Albert Gobeille (page 97).

LEGENDARY LOCALS

OF

JAMESTOWN

RHODE ISLAND

Rosemary Enright *Sue Maden*

ROSEMARY ENRIGHT AND SUE MADEN

Delia H Klingbeil

LEGENDARY
LOCALS

Legendary Locals is an imprint of Arcadia Publishing
Charleston, South Carolina

Printed in the United States of America

Library of Congress Control Number: 2013947541

For all general information, please contact Arcadia Publishing:
Telephone 843-853-2070
Fax 843-853-0044
E-mail sales@arcadiapublishing.com
For customer service and orders:
Toll-Free 1-888-313-2665

Visit us on the Internet at www.arcadiapublishing.com

Dedication
To the people of Jamestown who care about their history and have collected and preserved the records of their community.

On the Front Cover: Clockwise from top left:
Susan Stillman, midwife, with the Army Mother's Club (Courtesy of the Jamestown Historical Society, page 75); Capt. Abbott Chandler, boat livery owner (Courtesy of the Jamestown Historical Society, page 55); Rear Adm. Spencer S. Wood, retired Navy officer (Courtesy of the Jamestown Historical Society, page 67); Capt. Archibald F. Arnold, ferryboat captain (Courtesy of the Jamestown Historical Society, page 26); Sarah Jane Clarke, telephone operator, and her sister, Clara (Courtesy of the Jamestown Historical Society, page 104); Donald Richardson, longtime employee of the Jamestown & Newport Ferry Company (Photograph by Delia Klingbeil, page 44); Mary Miner, historian (Courtesy of the Jamestown Historical Society, page 112); Evelyn Law, dancer (Courtesy of the Jamestown Historical Society, page 123); and Peleg Carr, farmer (Courtesy of the Jamestown Historical Society, page 33).

On the Back Cover: From left to right:
The Jamestown Bridge Commission (Courtesy of the Jamestown Historical Society, page 58); Preston E. Peckham, town clerk and auctioneer, with his wife, Katherine (Courtesy of the Jamestown Historical Society, page 56).

CONTENTS

ACKNOWLEDGMENTS

Many people helped with this project and we thank them all. We are most deeply indebted to our photographer, Delia H. Klingbeil, who has photographed objects in the Jamestown Historical Society collection as well as living individuals we wished to include. Without her, we would have been unable to complete this project.

The knowledge and resources of the Jamestown Historical Society Collections Committee have been invaluable. The Jamestown Town Clerk's office—Town Clerk Cheryl Fernstrom, Deputy Town Clerk Karen Montoya, and Assistant Town Clerk Heather Lopes—helped us check dates and gave us access to the early records of the community. The staff at the Jamestown Philomenian Library was always helpful, and the library's collection of special materials, such as microfilm, genealogical information, local history, and indexes to the *Jamestown Press* and local history collection, was very useful. The *Jamestown Press*, in addition to supporting the Jamestown Historical Society over the years by publishing historical articles and columns, encouraged us and gave us access to its publications and photographs. Many other individuals and organizations generously lent us photographs; their contributions are acknowledged in the text.

Joyce Allphin and Ralph Klingbeil reviewed the whole book, and John W. Kennedy, director of education at the Naval War College Museum, reviewed references to US Navy personnel. Many of the individuals whose family members are described here fact checked their family's entries.

The Jamestown Historical Society Collections Committee—on which we both serve—as well as our friends and relatives, greeted our absorption in the project with good humor and tolerated our distraction with grace. We thank them for their support.

Unless otherwise noted, all images appear courtesy of the Jamestown Historical Society, which will receive proceeds from the sale of this book. The notation (DHK) in the courtesy line acknowledges photographs by Delia H. Klingbeil, all of which will be added to the society's collection.

INTRODUCTION

Native Americans lived on Conanicut Island, the largest of the three islands that comprise the town of Jamestown, from at least 3000 BCE. They prospered there for over 4,500 years. Settlement of Rhode Island by refugees from the Massachusetts Bay Colony began in Providence in 1636 and quickly spread south along the bay. In 1637, the Narragansett sachems Canonicus and Miantonomi sold access to "the marsh or grasse" on Conanicut Island to Newporters who brought their sheep to graze in the plentiful meadowlands here. Twenty years later, a company of 101 men signed a pact to purchase the land itself. Seven of the group—who together had agreed to contribute over 20 percent of the purchase price—were appointed trustees "to make a full and firm purchase" of the island and to enforce the details of the prepurchase contract. Of the seven only two—Benedict Arnold and Caleb Carr—took serious interest in developing the island. Even they did not leave the comforts of Newport but instead settled their children on the new lands or leased to tenants.

Jamestown was incorporated as a town in 1678, and for about 100 years the town enjoyed increasing prosperity. The lighthouse at Beavertail, the third oldest on the East Coast, was built to guide sailors into Newport harbor. Ferries carried the agricultural products of the island's farms and fisheries to Newport, and from there they reached markets as far away as the West Indies. The Jamestown seal—a shield with a green field surmounted by a silver sheep—was adopted, reflecting the importance of animal husbandry in the town's agriculture.

With the start of the American Revolution, Jamestown's prosperity came to an abrupt halt. On December 10, 1775, British soldiers and marines landed at the East Ferry and marched across the island to the West Ferry and back, burning all buildings within reach. The following December, British and Hessian soldiers occupied the island. Some of the farmers fought back, but most fled to the mainland. By October 25, 1779, when the British evacuated Jamestown, the island lay in ruins. The Quaker meetinghouse, which had been used as a hospital, was in rubble. The stone Beavertail lighthouse still stood, but the light had been destroyed. The trees had been cut to provide warmth for the occupying army. Any farm animals that had not been removed to the mainland had been killed for food. Brush had spread across the untended land.

Recovery after the Revolutionary War was slow. The Beavertail lighthouse was relit almost at once and was replaced in 1856. A lighthouse was erected on Dutch Island in 1827 and rebuilt in 1857. The ferries ran again, but Newport was no longer a flourishing marketplace for the island's produce. Some old families, such as the Remingtons and Underwoods, left or died out. The Carrs and Weedens remained and were joined by the Watsons as the leading families in town. Little else changed. Jamestown remained a rural community sustained by its farmers and fishermen. A hundred years after the Revolution, its population was only 378, about two-thirds of what it had been when the war began.

The last three decades of the 19th century were among the most dramatic and exciting in the town's history. In 1873, the Jamestown & Newport Ferry Company, a private corporation in which the Town of Jamestown was the majority stockholder, launched the *Jamestown,* a steam-powered ferry, on the run between Newport and Jamestown. Reliable ferry service made Jamestown accessible, and the ocean breezes and absence of industry made it a healthful alternative to city living. Jamestown's era as a summer resort had begun.

Several large hotels were built at East Ferry. William H. Knowles's Bay View, built in 1872, and expanded by both him and his son Adolphus, was the first. Stephen Gardner's Gardner House was built next. By the early 1890s, hotels within easy walking distance of East Ferry could accommodate more than 1,000 guests. The hotels offered not only rooms and three meals a day, but laundering, tailoring, entertainment, and even the occasional loan of cash to visitors without local banks.

Conanicut Park, the summer colony at the northern end of the island, had its own dock and direct steamboat access up the bay. It attracted prominent Rhode Islanders, such as Gov. Henry Lippitt and his family and wool magnate Charles Fletcher. At the opposite end of the island near what is now Fort Wetherill, artist William Trost Richards, industrialist Joseph Wharton, and other wealthy Philadelphians built summer homes on the high rocky outcroppings along the scenic coast. Nearer the village, James Taussig and his colleagues from St. Louis established the private community of Shoreby Hill. Narragansett Bay was home to portions of the US Atlantic Fleet, and many of the officers who served in the fleet or trained at the Naval War College in Newport spent their summers in or retired to Jamestown.

The town's population grew. The summer families brought their own servants, often Irish or African American, some of whom remained as year-round residents. Newcomers appeared to build the homes and care for the properties of the summer residents. Immigrants from the British Isles and northern Europe came before the end of the 19th century. Early in the 20th century, immigrants from the Portuguese Azores—among them the Neronhas, Andrades, and Tiexieras—began to arrive. By 1930, about 20 percent of the households were presided over by immigrants or children of immigrants. The town's pool of political leaders expanded with the increased population. Town leaders still often carried the surnames of the original proprietors, for example, Charles E. Weeden and George C. Carr. Newcomers from England and northern Europe, such as Samuel Smith and Ferdinand Armbrust, gained political strength and served as councilmen and state representatives. The Portuguese immigrants did not integrate as easily. The first person of Portuguese descent to serve on the town council was Frank E. Furtado, who was elected in 1929.

The Great Depression ended the prosperity of the resort era. Throughout the 1930s, the town struggled to keep its residents employed. At the end of the decade, it faced a tragedy of a different kind. In September 1938, a hurricane barreled up the East Coast. The tidal wave it created slammed into Jamestown just as a school bus carrying eight children, all of whom lived on Beavertail, was trying to cross the road between Mackerel and Sheffield Coves. Only the driver and 12-year-old Clayton Chellis survived. It was a dismal end to a dismal decade.

Over the next few years, as the war in Europe escalated into World War II, Jamestown entered a new phase. The Army had maintained three forts in the town since before World War I: Fort Greble on Dutch Island, Fort Getty south of Dutch Island Harbor, and Fort Wetherill in the Dumplings. A torpedo and naval air test facility had been built on Gould Island in the 1920s. A new Army-Navy outpost was established at Beavertail, and the observation posts on Prospect Hill above the 1776 Conanicut Battery were reactivated. The Torpedo Station on Goat Island in Newport, which employed many Jamestown residents, increased production. The war effort and the 1938 Hurricane that had temporarily destroyed the ferry system on the West Passage and interrupted communication between the island and the rest of the world, both contributed to an awareness of the need for a less vulnerable way to get to and from the island.

Construction of the Jamestown Bridge between Conanicut Island and the western mainland was begun in November 1938 and completed in July 1940. The cost of the bridge was shared almost equally between the federal government's Public Works Administration (PWA), which financed and oversaw large projects between 1933 and 1943, and the Town of Jamestown. As with the ferry, the people of Jamestown were responsible for creating their own transportation system.

For Jamestown, the immediate effects of the bridge were indistinguishable from the effects of the war and, for the length of the war, the town flourished. With the removal of the military after the war, the economy shrank. The return of the men who had fought in the war further stretched the town's shrinking resources. The bridge and the depressed economy of the town, however, made Jamestown for the first time attractive to industry. In 1956, Commerce Oil, backed by Gulf Oil, proposed building a refinery at the North End. Many residents, including the town council president Dr. Albert Gobeille, welcomed the proposal. Others, especially the farmers in the area of the proposed refinery and those who had experience with refineries in other states, such as Dr. William W. Miner, opposed it. Tensions ran high for four years as each group sought to define a town that suited their needs. Changes in the

international oil scene caused Gulf Oil to drop the project in 1960, but the effects of the dissension were felt for many years.

With a way to get to the mainland that was not dependent on weather, residents could more easily work off island, but the toll on the bridge was high as the town planned to use the toll money to pay off the bonds and to keep from going further into debt for maintenance. The convenience of the bridge could not attract residents if they could not find work, and in the 1950s, the inflow of permanent residents was slow. Families still came only for the summer, and wage-earners commuted to their jobs for two or three months before taking their families home. Some new full-time residents were retirees looking for the peace that the island offered. The opening of the Newport Pell Bridge in 1969 changed the dynamics again. In the 10 years that followed, the town grew by 38 percent, from 2,800 to more than 4,000 residents, and the new Jamestown Verrazzano Bridge across the West Passage, completed in 1992, attracted even more residents.

Jamestown today is a quiet, primarily residential community. An interest in preserving the history of an earlier Jamestown was displayed at the beginning of the 20th century when Mary Rosengarten led the campaign to save the Jamestown windmill. The drive to preserve continued in the early 21st century with the reclamation, under the leadership of Edwin W. Connelly, of the 1776 Conanicut Battery. A strong commitment to the environment, exemplified by the opposition to Commerce Oil, is ongoing with the town's conservation commission. Artists still capture the beauty of the island, and, through their work, encourage both historians and environmentalists.

The village retains its small-town character and the island's inhabitants—new and established—are united in their desire to maintain the rural quality and peacefulness that originally attracted them to the island.

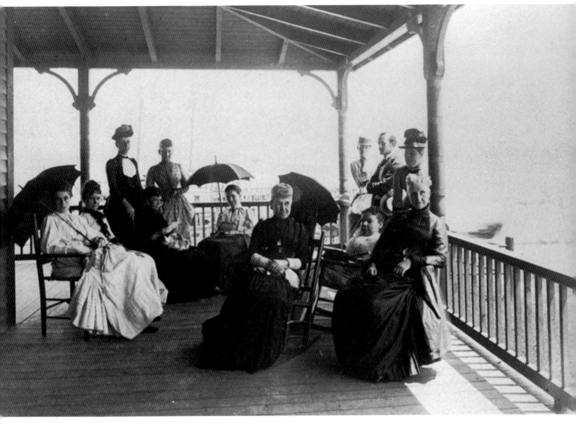

Visitors at Gardner House
At the height of Jamestown's resort era in the early 20th century, some families made their homes in the full-service hotels that lined the Jamestown waterfront. Others, like Mary Rosengarten (center) and her friends, often gathered there.

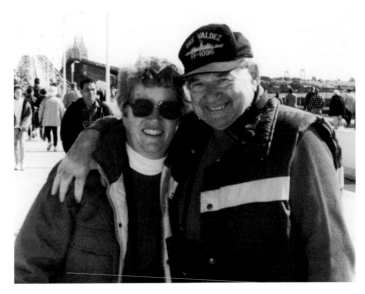

Walking the Jamestown Verrazzano Bridge
Sue and Phil Maden joined 40,000 other people on Saturday, October 17, 1992, to walk across the just completed Jamestown Verrazzano Bridge to Saunderstown. (Courtesy of Sue Maden.)

CHAPTER ONE

From Indian Campground to English Village

When the Narragansett sachem Canonicus (c. 1565–1647) sold Aquidneck Island to English settlers in 1637, the sale included the right to use the grasses and open fields of Conanicut and Dutch Islands. Twenty years later, a consortium of 101 men, most of them from Newport, bought both islands from the Narragansett sachem Cashanaquont. The sales agreement included a clause requiring the Indians to leave the islands and not return.

Although none of the men who invested heavily in the purchase of Conanicut Island ever made their homes here, they greatly influenced the growth and stability of the new community. Benedict Arnold (1615–1678), an ancestor of the Revolutionary War traitor, bought up land as smaller investors showed an inclination to sell and soon became the largest landowner on Conanicut. Caleb Carr (1624–1695), the first of a long line of Carrs to influence the island's growth, established the first ferry service to Newport and installed his eldest son, Nicholas, on his land. In 1678, Caleb Carr petitioned the Rhode Island General Assembly to incorporate the settlement on Conanicut Island as the town of James-Towne.

In the century before the American Revolution, Jamestown grew prosperous as an agricultural community exporting to the commercial center of Newport. Newcomers, including Capt. Thomas Paine (1632–1715)—a privateering friend of Captain Kidd—and absentee landlords from Boston and Providence, purchased farms from the original settlers.

The British occupied Jamestown during the Revolution with disastrous effect. The town government moved to the mainland, and Benjamin Underwood (c.1730–1790) continued to work for the town while in exile, with devastating personal consequences. The state ordered the evacuation of Jamestown's farm animals to prevent them from becoming provisions for the British and Hessian troops. With the animals went the farmers, many of them never to return. Twenty families, including the Quaker Nicholas Carr (1732–1818), remained, as did the more war-like John Eldred (1720–1784)—both creating legends around their resistance to the occupying forces. After the war, newcomers, such as Job Watson (1744–1812), acquired the abandoned farms and began the long process of rebuilding the town.

No contemporary portraits or drawings of the settlers remain. Many early Jamestown residents were Quakers and avoided the self-aggrandizement that a portrait implied, though most were simply without the means to commission such a luxury.

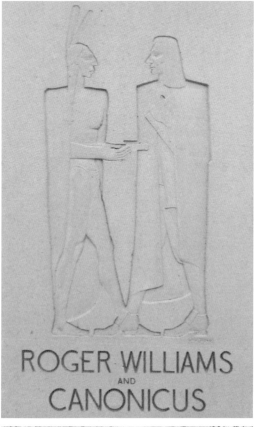

ROGER WILLIAMS
AND
CANONICUS

Canonicus
Canonicus was the Narragansett sachem when Englishmen arrived in New England. He was a wily politician and, after an initial display of defiance, worked peacefully with the newcomers. He sold Aquidneck Island and the right to use the grasslands of Conanicut Island to dissidents from the Massachusetts Bay Colony in 1637. Some historians believe he was using the English to protect the southern Rhode Island Narragansett from the Wampanoag, their enemies to the east. He probably never met with Roger Williams on Conanicut Island.

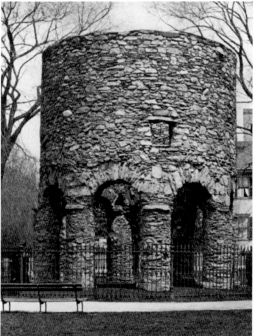

Benedict Arnold
Arnold came to New England with his father in 1635. He learned the Narragansett language and traded extensively with the natives. He is believed to have built the pictured stone tower in Newport as a mill. In the contract among the colonists who bought Conanicut Island in 1657, Arnold agreed to pay five percent of the purchase price in return for about 250 acres of the island. He eventually owned more than 1,400 acres.

Caleb Carr

Carr, whose signature is near Arnold's on the Conanicut Island prepurchase agreement, established the first ferry service between Newport and Jamestown. In 1678, he and Francis Brinley successfully petitioned the Rhode Island General Assembly to incorporate James-Towne. Carr drowned in 1695, seven months after being elected Rhode Island governor. One report says he was loading barrels of rum onto his ferry when he fell to his death.

Cashanaquont

Cashanaquont was called a "drunk" by Roger Williams, and historians speculate that he did not understand that in accepting £100 and "several gifts of value" he was relinquishing all claims to Conanicut and Dutch Islands. The sale was ratified by the "exchange of turf and twig." Catharine Morris Wright (page 118) created this impressionist depiction of the event for Jamestown's tercentenary celebration in 1957. (DHK.)

Capt. Thomas Paine
Under a privateering commission from the governor of Jamaica, Paine spent the 1670s and 1680s harassing Spanish shipping in the Bahamas. After his retirement to Jamestown, Paine continued his friendships with the privateers and pirates he had met on his travels, sometimes acting as their agent. Capt. William Kidd visited in 1699, and it is rumored that Kidd buried his treasure on Paine's Jamestown estate.

Gov. Thomas Hutchinson
Governor Hutchinson, the Loyalist governor of Massachusetts from 1758 to 1774, was one of early Jamestown's many absentee landlords. From his home in Boston, he wrote letters to the Jamestown Town Council, complaining about the treatment of his tenants and about infringements on his rights as a landowner. He was generally ignored. (Courtesy of Massachusetts Historical Society.)

Nicholas Carr

Nicholas Carr was living on the Jamestown farm purchased by his great-grandfather Gov. Caleb Carr when the colony of Rhode Island moved inexorably toward rebellion. As Quakers, the Carrs refrained from joining the military uprising. Their faith, however, did not stop Nicholas and his brothers and cousins from backing the rebels. In June 1776, they published their support in the *Newport Mercury*, promising not to "afford assistance of any sort or kind, to [British] fleets or armies, during the continuance of the current war. . . ." Nicholas worked the farm throughout the war. Despite his pacifism, he clashed with the British forces that occupied the island from December 1776 until October 1779. On one occasion, he responded to a swipe from an officer's cane by taking the cane away from the offender and beating him with it. According to Carr family tradition, Nicholas spent three days on a British ship, threatened with hanging if he did not kneel and kiss the British officer's ring. He refused. He was released following the intervention of a Tory neighbor. Nicholas's descendants celebrated their family history with theatricals at the Carr Homestead on the country's 150th anniversary in 1926.

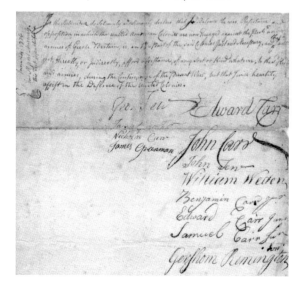

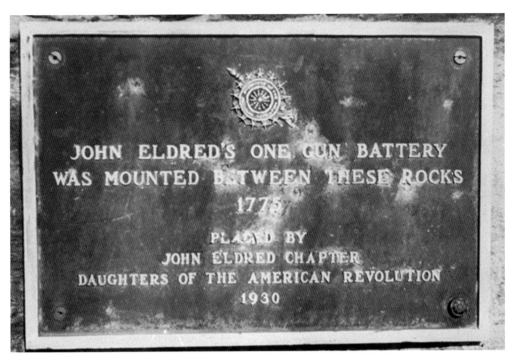

JOHN ELDRED'S ONE GUN BATTERY WAS MOUNTED BETWEEN THESE ROCKS 1775 PLACED BY JOHN ELDRED CHAPTER DAUGHTERS OF THE AMERICAN REVOLUTION 1930

John Eldred
Eldred owned a farm midway up the island on the East Passage. According to a legend that has been memorialized by the Daughters of the American Revolution plaque, he propped a cannon barrel between two large boulders, gathered rocks to use as cannon balls, and lobbed the rocks at passing British ships. Most shots missed, but finally one tore a mainsail. The English captured the cannon, but Eldred escaped to the mid-island marshes.

Benjamin Underwood
Underwood was Jamestown Town Clerk throughout the American Revolution. In 1780, the town owed him about $7,000, and he borrowed money against that expectation to rehabilitate his farm, which had been destroyed during the British occupation. He was never paid, and a year later he was thrown into debtor's prison, where he languished for 53 months. He built wooden boxes and pails of the type pictured to get cash for food, since at this time prisoners were not fed by the government. (Courtesy of the Newport Historical Society.)

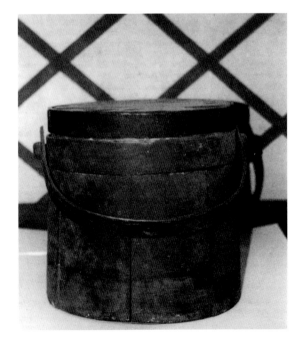

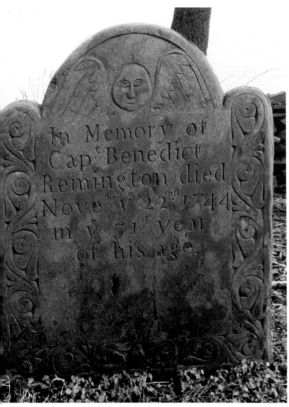

Capt. Benedict Remington
The Remingtons came to Jamestown sometime before 1690. Stephen Remington and his son Gershom, both officers in the Jamestown militia, were in charge of the watchtower at Beavertail during Queen Anne's War (1702–1713). Gershom's son Benedict was a captain in the militia when he died in November 1744. His is the earliest grave in the Jamestown town cemetery. (DHK.)

Benjamin Remington
The Remingtons continued to be active in town affairs. Benedict's cousin Benjamin, whose will (pictured) was probated in 1820, was responsible for barring suspected smallpox patients from the island and was overseer of the hospital for smallpox treatment. Town meetings were often held at his house. He was one of the few men to rebuild his Narragansett Avenue home after it was burned down by the British in 1775. (Courtesy of the Jamestown Town Clerk.)

Oliver Remington

Benjamin Remington's grandson Oliver was born in Jamestown in 1789 and married Sarah Humphrey of Tiverton in 1811. Like many young Jamestowners in the post-Revolution period, he left the island, and he and his wife settled in Ohio. The letters between the Rhode Island and Ohio families capture their hope for a better life and the hardships they faced. (Courtesy of Joylee Watson.)

Job Watson

The population of Jamestown dropped from 563 in 1770 to 323 in 1780, a decrease of more than 40 percent. Watson came from South County to take advantage of the void. He arrived with few possessions, as this inventory from 1784 shows. The town council almost sent him back because it feared he would not be able to earn a living and would become a public charge. Watson rented a farm at the northern tip of the island and within 20 years was the largest landowner in Jamestown.

CHAPTER TWO

Getting Here

Jamestown is a town of islands, made up of Conanicut Island, Dutch Island, Gould Island, and a number of small islets known collectively as "dumplings." Before 1940, when the first Jamestown Bridge was built, the only way to reach Jamestown was by boat. Lighthouse keepers, ferrymen, and, in recent years, the men who built and maintained the bridges were central to island life.

Conanicut Island's position in the middle of the entrance to Narragansett Bay meant that as early as 1667, a "watch house" and beacon were kept at Beavertail, the southern point, and, in 1749, a lighthouse was built there. Later two other lighthouses—one on Dutch Island and one at the North End—were built. Lighthouse keepers and their families lived at the lighthouses until the last light was automated in 1972.

Until the 1870s, the ferries on both sides of the island depended on the wind. Steam-ferry service between Jamestown and Newport started in 1873 and was introduced on the Jamestown-Saunderstown route in 1888. The Jamestown & Newport Ferry Company, which initiated the steamboat service, was a joint venture of the Town of Jamestown and some of its prominent citizens. The town owned a controlling 60 percent of the stock, and the voters of Jamestown elected the company's officers. The first president elected to direct ferry operations was George C. Carr (1818–1900), thus continuing the Carr family's long association with the East Passage ferry.

For 96 years, the ferries of the Jamestown & Newport Ferry Company transported residents, visitors, and transients to and from the island. Only Stillman Saunders (1855–1911) challenged its control of lower Narragansett Bay. The captains and managers of the ferry company were important members of the community, and the company was one of the town's largest employers.

The Jamestown Bridge across the West Passage was, like the ferry company, a town venture, although much of the construction cost was paid for with a Depression-era grant from the federal government. The men who lobbied for and guided the construction of the bridge included members of Jamestown's oldest families, such as George Caleb Carr (1888–1945), and newer arrivals, such as Capt. Louis A. Kaiser (1870–1939).

Talk of a bridge from Jamestown to Newport had begun even before the Jamestown Bridge was finished. In 1954, the state legislature created the Rhode Island Turnpike and Bridge Authority. Although a 1960 referendum on an East Passage bridge lost in Jamestown almost two to one, by that time the bridge was a state rather than a local issue. In 1964, a bond issue to fund the bridge was approved, and the Newport Pell Bridge was completed in 1969.

The latest link with the outside world was the Jamestown Verrazzano Bridge, which replaced the 1940 Jamestown Bridge in 1992.

Abel Franklin
In 1740, Franklin was ordered by the town council to build a beacon at Beavertail. When the simple beacon proved unable to ensure the safety of ships entering Narragansett Bay, Franklin was appointed to the committee to build a lighthouse, shown here. He served as lighthouse keeper at Beavertail from the completion of the lighthouse in 1749 until 1790.

Capt. William W. Wales
Wales was keeper at two of Jamestown's three lighthouses. After serving in the Union army during the Civil War, he was given charge of the Dutch Island Light and moved to the 81-acre island with his wife and three sons. Wales was transferred to the Beavertail Light in 1873 and died on station there in 1895.

Silas Gardner Shaw and his wife, Ann Neal Goddard Shaw
Shaw was keeper at the Beavertail Light for two almost contiguous periods—1858 to 1862 and 1863 to 1869—during the time when lighthouse keepers were political appointees. During most of the second period, his wife, Ann, was the assistant keeper. Three Shaw children were born at the lighthouse: Joseph (1862), Edward (1863), and Silas Jr. (1865).

George T. Manders
Manders spent 24 years at Beavertail Light; he was assistant keeper from 1915 to 1919 and continued as keeper until 1938. As a boy, Manders crewed on a whaling expedition. He later served on US Navy square riggers in the China Sea. He was noted for his tall tales about these and other exploits.

21

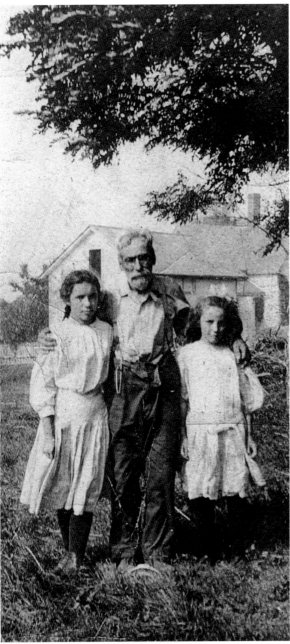

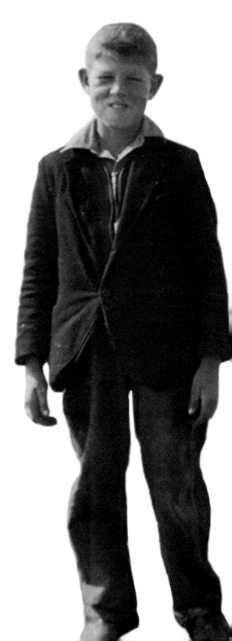

Clayton Chellis (BELOW)
The school bus carrying Clayton Chellis, son of Beavertail Light keeper Carl Chellis, his sister Marion, and six other students was taking the children home when the hurricane of September 21, 1938, hit Jamestown. Waves swept the bus into Sheffield Cove. Clayton was the only child to survive. He later joined the Navy and, ironically, drowned in a swimming accident in California.

Horace Arnold (ABOVE)
Arnold, pictured with his granddaughters, led a harrowing life before he was appointed keeper at the Conanicut Light at the North End in 1886. He survived two shipwrecks in the 1860s. In 1875, he was keeper of the Conimicut Point Light in the upper bay when a storm swept away the keeper's cottage. Arnold spent many hours drifting around the bay on an ice floe. (Courtesy of Sid Webber.)

Capt. Joseph Lester Eaton
Until 1888, ferries between Saunderstown and Jamestown were wind-driven. Eaton was the last sail-ferry captain. He made four scheduled trips a week. At other times, a would-be traveler opened a large door on the water side of the ferry house. The house was white; the inside of the door was black. When Eaton saw the signal, he sailed across to pick up his passenger.

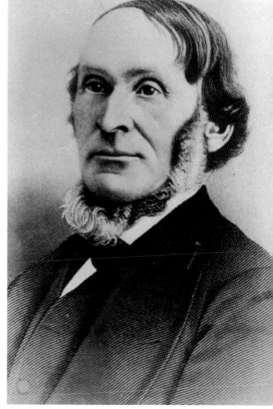

George C. Carr
The Jamestown & Newport Ferry Company was incorporated in 1872 to bring steam-ferry service to the Newport-Jamestown crossing. George C. Carr, a descendant of the owner of the first Jamestown-Newport ferry, was elected president. Under his leadership, a new wharf was built, and on May 12, 1873, the coal-powered side-wheeler *Jamestown* made the first of five scheduled daily trips between Newport and Jamestown.

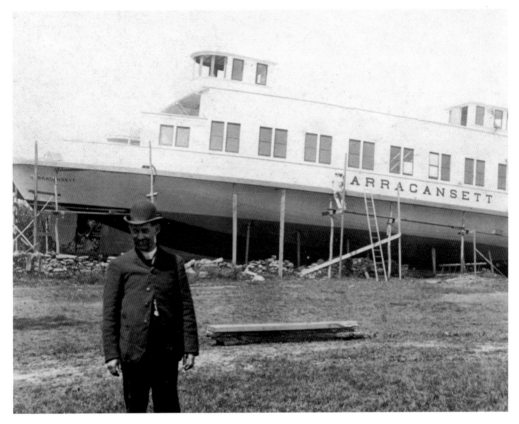

Thomas Willet Stillman Saunders

For 30 years, the Jamestown & Newport Ferry Company controlled transportation across Narragansett Bay between Saunderstown and Newport with Jamestown and Fort Greble on Dutch Island as way-stops. In 1906, Stillman Saunders formed the Narragansett Transportation Company to compete for the bay traffic.

Saunders was born into a family of sailors and shipwrights who had established a marine construction and repair facility on the mainland across from Dutch Harbor in the mid-19th century. In his own shipyard, Saunders built four ferryboats, especially designed for the Narragansett Bay runs. Two of his ferries were smaller than those of the Jamestown & Newport Ferry Company. However, with four boats he could, when necessary in the summer months, schedule one trip every half hour on both the East and the West Passages. He set up a machine shop at his East Passage wharf and, between that and his facility in Saunderstown, could quickly repair mechanical failures on any of his ferryboats. Three of the ferries had built-in tanks below decks that had been designed to carry water from the mainland to Dutch Island for the Army at Fort Greble since Dutch Island has no natural water source.

Soon after he put the ferries in service, Saunders purchased two electric buses to carry his passengers across Jamestown. He installed a dynamo on his ferryboat *Newport*—at the time the largest and fastest ferry on the bay—to charge the buses' batteries. When he applied to Jamestown for a jitney license, his application was denied. He was, after all, in competition with the town-owned Jamestown & Newport Ferry Company. Undeterred, Saunders ran the buses free of charge, picking up passengers from incoming ferries of both companies and delivering them to his own wharf on the other side of the island. He quickly received his license.

Saunders was the driving force behind the Narragansett Transportation Company, but ill health forced him to sell it shortly before his death in 1911. (Courtesy of Arthur S. Clarke III.)

Capt. Reuben W. Garlick
Captain Garlick, a son and grandson of ferrymen, began his seagoing career at 16 by sailing coastal vessels out of New York. He captained Narragansett Transportation Company ferries in the 1900s and, after the company folded, worked for the Jamestown & Newport Ferry Company. He retired in 1952 after making, by his own estimate, over 254,000 trips across one or the other of the lower Narragansett Bay passages.

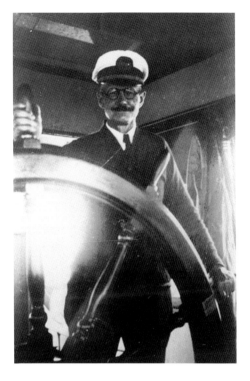

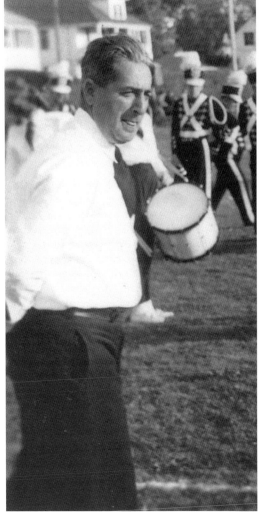

Capt. John Boone
A manager of the Jamestown & Newport Ferry Company as well as a captain on the ferries, Boone was active in community affairs. He organized and directed Jamestown's American Legion Girls' Drum and Bugle Corps, which won numerous trophies in the 1940s, and the men's Drum and Bugle Corps for the Newport Boys' Club. (Courtesy of Norma Moll Walsh.)

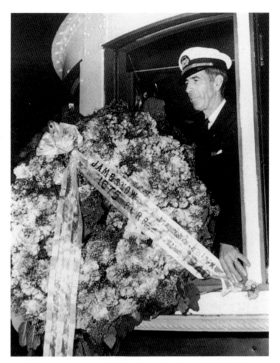

Capt. Archibald F. Arnold
Captain Arnold, a ferryboat captain on the Jamestown-Saunderstown run from 1917 to 1940, placed a wreath on the *Hammonton* for its last trip across the West Passage on July 27, 1940. Arnold was an irascible seaman and was once brought to court for insulting the directors of the ferry company. The matter was settled amicably with an apology.

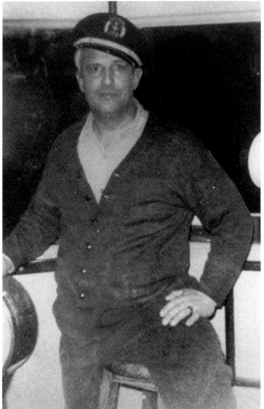

Capt. William A. Pemantel Sr.
Ferryboats under Captain Pemantel's command carried passengers and vehicles back and forth between Newport and Jamestown for almost 30 years after the West Passage ferry stopped running. Then, on June 28, 1969, the bridge connecting Newport and Jamestown opened, and Pemantel took his last official trip.

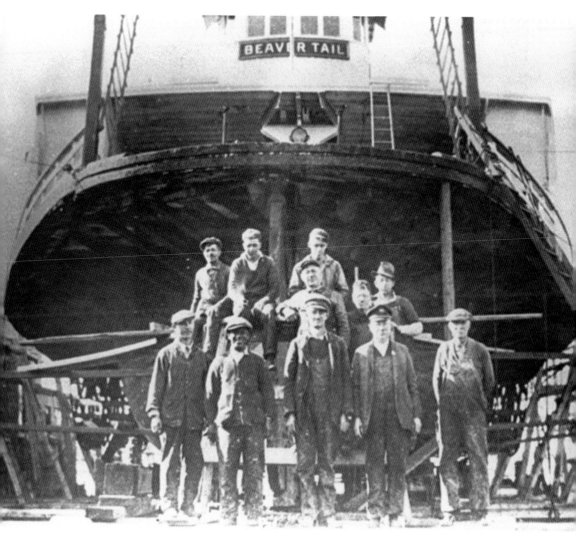

The Work Crew on the *Beaver Tail*
The captains drove the ferryboats, but the crews kept them going. The *Beaver Tail* was built in 1896 and was in service, usually on the West Passage, from 1896 until 1923. The automobile deck was totally redesigned in 1932, which is probably when this picture was taken, and the ferry was used occasionally until 1938. The hurricane on September 21, 1938, blew the *Beaver Tail* ashore at the North End of Conanicut Island. The keel was broken and the hull was punched, leading the boat to be sold as salvage. Posing on the deck of the *Beaver Tail* at the Newport shipyard are, from left to right, (first row) unidentified; William L. Netter, watchman and porter; Daniel J. Watson, deckhand; Patrick J. Drury, engineer; and Frederick Littlefield, helper; (second row) Walter E. Bollons, blacksmith and seaman; William Everett Johnson, engineer; and Timothy S. McGrath Jr., mechanic; (third row, seated) Joseph Miller, fireman and oiler; Oscar B. Lathan, able seaman; and William Foster Caswell, fireman and later a manager and director of the ferry company.

Capt. Louis A. Kaiser
The single most important project to affect change in Jamestown during the first half of the 20th century was the completion of the Jamestown Bridge in 1940. Captain Kaiser, US Navy (Ret.), championed the idea of the bridge in the early 1930s. He chaired the original Jamestown Bridge Committee in 1933 and 1934 and shepherded the bridge through the first set of approvals from the state and federal governments, weathering a series of setbacks in acquiring funding. Finally, in October 1938, the Public Works Administration (PWA), a federal Depression-era agency to fund public improvements, approved a grant of $1,404,000, about 45 percent of the cost of the bridge. Bonds were issued for the rest, and the first piles were driven before the end of the year, as was required by the PWA grant. Captain Kaiser died in April 1939 while the bridge was under construction.

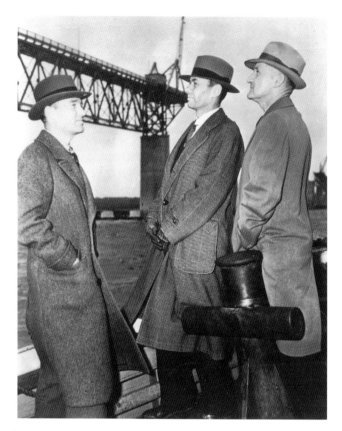

Charles H. Brooks

The Rhode Island General Assembly created the Jamestown Bridge Commission in 1937. However, final approval of construction was still in question the following fall when a Jamestown town meeting was called to enable the town's voters—who would be responsible for the bonds issued to pay for 55 percent of the bridge—to have a final say on its construction. Between the meeting announcement and the day of the meeting, the 1938 Hurricane devastated the area, destroyed the West Passage ferry docks, and, for a time, isolated the island. The vote at the town meeting on September 26 was 240 to 23 in favor of the bridge.

Once begun, bridge construction went quickly. The Jamestown Bridge Commission, whose members were elected by the voters of Jamestown, kept close watch over the progress of the construction and were in almost daily contact with the contractors and the PWA administrator, John M. Carmody. They recessed, rather than adjourned, each session in order to be available on short notice in emergencies.

The commissioners had hoped to have the bridge completed and open for traffic by May 1940 in order to profit from the summer traffic. That overly optimist estimate was revised several times, and it wasn't until June 12 that the main span was joined in the center. The bridge opened for traffic on July 27, only 18 months after the first test pilings in November 1938. Perhaps even more remarkable is that the total cost, $3,002,218.02, was almost $118,000 less than budgeted. A three-day dedication followed on Friday, Saturday, and Sunday, August 2 through 4.

Rhode Island governor William H. Vanderbilt (left) inspected the bridge site in April 1940. With him are Eugene Macdonald (center), consulting engineer from Parsons Brinckerhoff, the firm that designed the bridge, and Charles H. Brooks, who was vice chairman of the Jamestown Bridge Commission as well as general manager of the Jamestown & Newport Ferry Company. Throughout the 1930s, Brooks had campaigned aggressively for the bridge. From 1940 to 1946, he was general manager of both the bridge commission and the ferry company.

Commodore Cary Walthall Magruder
For its first 15 years, the Jamestown Bridge Commission issued no reports or minutes, and rumors of corruption surfaced. Commodore Magruder (shown with his daughter Polly) joined the commission in 1951 with the avowed intent of cleaning up the commission and making management records public. As commission chairman in 1953, he published the first administrative report, covering the years 1937 to 1952. M. James Vieira, who had been on the commission since its inception and was general manager from 1949 to 1953, resigned the same year. (Courtesy of James C. Buttrick.)

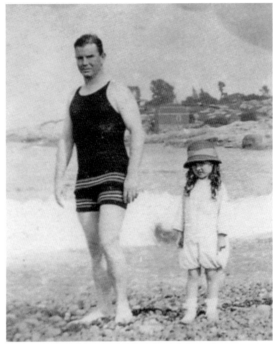

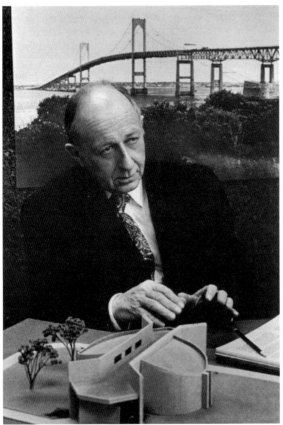

Walter S. Douglas
Douglas was senior partner in Parsons Brinckerhoff, the engineering firm that designed both the 1940 Jamestown Bridge and the 1969 Newport Pell Bridge, when the latter bridge was completed. He and his wife, Jean, retired to Jamestown in 1974. As president of the taxpayers association, he fought against zoning changes that would have allowed condominiums to be built at the North End. (Courtesy of Parsons Brinckerhoff.)

CHAPTER THREE

An Island Community

An island is a special place to live. The waters that surround the town clearly define who is "us" and who is "them." Islanders do not wander by accident into a neighboring town, nor is island life easily or quickly influenced by changes in nearby communities.

Before the Jamestown Bridge was completed in 1940, movement beyond town borders was tuned to the ferry schedule, and no one, unless he owned his own boat, left or arrived on the island between 11 p.m. and 6 a.m. The early 19th-century farmers seldom left the island at all. Peleg Carr (1807–1884) farmed the land acquired by his four-times great-grandfather, and his sons followed suit. Some of the neighbors followed the sea. Isaac Briggs (1820–1907), whaler and sea captain, lived at West Ferry, as did the men of the King family, who came from Block Island and made their living by piloting ships up the bay.

Late in the 19th century, as the ferries brought more and more summer visitors to the island, new residents arrived and created their own dynasties. Peter Armbrust (1847–1916) was a seafarer from Germany whose descendants remained on the island as plumbers and mechanics. Alton Head Sr. (1864–1958), the "dean of Rhode Island politics," bequeathed his political acumen to his son Alton Head Jr. (1906–1987) and on to the next generation. The Moll family—Charles (1894–1947), John (1898–1985), and Christina (1903–2002)—acquired the Jamestown garage in 1917. They intermarried with the local Littlefield and Walsh families. Walter Marley (1881–1950) settled in Jamestown while he helped set up the foundry at the Torpedo Station in Newport. His daughter Iona (1908–1994) stayed to open a nursing home, and her daughter and granddaughter continued as Jamestown businesswomen in her footsteps.

Rugged individualists and the occasional eccentric flourished, too. Oliver E. Sprague (1885–1956), who owned a team of oxen, was in demand for heavy farm work. Orville Minkler (1890–1957) kept to his West Ferry cottage, shunning contact beyond his neighborhood. Sergio Andrade (1900–1985), a newcomer from the Azores, found work caring for the summer homes that stood vacant for much of the year. Frank H.C. Rice (1869–1937), his wife, Olivia, Andrew Lodkey (1850–1936), and his wife, Melissa, were prominent members of the small community of African Americans who lived on the island year round.

South School, Class of 1885

In the early 1730s, Jamestown built its first schoolhouse of record. One hundred years later, there were two one-room schoolhouses, each with a single teacher for all grades. The South School, just north of Mackerel Cove, served the village and the farms on Beavertail. Children of families north of the Great Creek attended the North School, near Carr Lane. Attendance was low and the school year lasted only three months. The names of the students who attended the South School in 1885 resonate through the next 100 years of Jamestown history.

Pictured are, from left to right, (first row) Benjamin Cottrell, Philip Peckham, John Wright, Daniel Oxx, Charles Clarke, William Clarke, John J. Watson Jr., Allie Peckham, and Fred Hull; (second row) Anna Wright, Emilie Tennant, Annie Irish, Hattie Oxx, Ella Weeden (in chair), Mamie Knowles, Lizzie Oxx, and Lucy Gardner; (third row) Bertha King, Nettie Caswell Hull, Blanche Wright, Aggie Gill, the teacher Ralph Potter, Mary Clarke Hammond, Ella Caswell, Katie Gardner, William B. Gill, Hester Tennant, Phoebe Beviss, and ? Champlain.

The influx of summer visitors that followed the introduction of the steam ferries in 1873 brought new residents to the island and spawned a need for merchants, real estate agents, hotel managers, and construction managers who were better educated than the graduates of the country schools. Still, until 1898, Jamestown children were taught in one-room schoolhouses relatively close to the family farm. That year, the new four-classroom Carr School was opened in the village at the corner of Clarke and West Streets, and for the first time, the concept of progressing from grade to grade, rather than moving at different paces through different subjects, was introduced. Within 15 years, the Carr School was too small for the number of students, and in 1913–1914 an addition was built for the children of the burgeoning population.

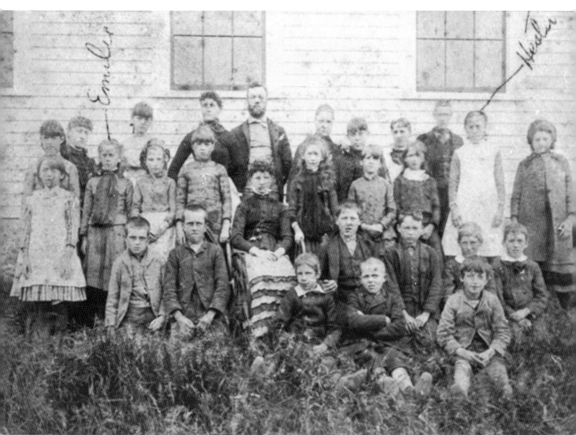

Peleg Cross Carr

Peleg Carr, the eldest of nine siblings, was born and raised on the homestead farm that his ancestor Gov. Caleb Carr had purchased in 1657. He was 16 when his father and mother died within five months of each other in 1822–1823. The three youngest children—Celia, 6, William, 5, and George, 4—went to live with aunts and uncles, but Carr and the other five children remained on the farm. Peleg took on the responsibilities of caring for the family and the farm, while his younger sister Mary, 15, ran the household. Carr was very successful as a farmer and over the years bought out his brothers' and sisters' interest in the homestead and purchased surrounding farmland. Like his forebears, he was active in town affairs and was at various times a member of the town council, the school committee, and a representative in the state legislature.

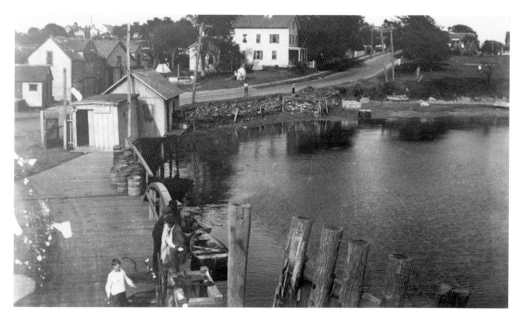

Capt. Isaac Bowen Briggs
Captain Briggs, who lived at West Ferry as ferryman and marina keeper, sailed out of Newport to the West Indies and South Atlantic before settling at Jamestown. For many years in the 1880s and 1890s, he was Jamestown's "Overseer of the Poor," responsible for what today would be called social services.

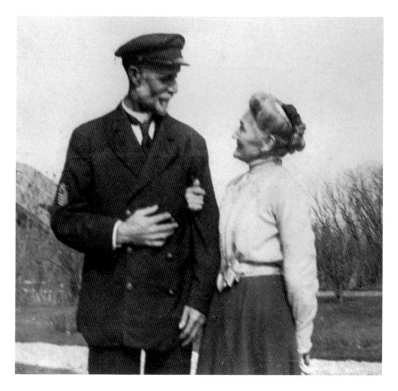

Capt. George H. Carr
Captain Carr, with his wife, Harriet, was not one of the ubiquitous Jamestown Carrs. He came to Jamestown as captain and superintendent of the yachts belonging to Joseph S.L. Wharton, the builder of Clingstone. He was a member and chairman of the Jamestown School Committee.

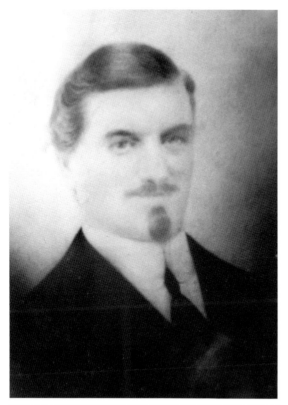

Andrew Jackson King
King moved to Jamestown from Block Island about 1885 and settled in the West Ferry area. He was a skilled pilot and competed with pilots from Block Island to bring ships in and out of Narragansett Bay and to safe berths in Providence. Although Rhode Island passed laws governing piloting in 1867, they did not immediately stop the "pilot wars" between the rival groups. (Courtesy of Lois King Winn and Debra Newton Carter.)

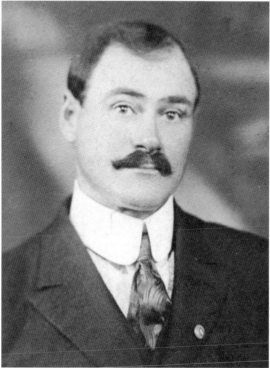

Capt. Clarence H. King
Andrew Jackson King's son Clarence was one of the most aggressive of the Jamestown bay pilots. A 1903 newspaper story reported that he and his brother Andrew Thomas rowed from East Ferry to a mile and a half southwest of the Brenton lightship in a nor'easter to reach a steamer that had signaled for a pilot to guide it to Providence. (Courtesy of Lois King Winn and Debra Newton Carter.)

Ferdinand Armbrust
Peter Armbrust's son Ferdinand was a plumbing contractor with a wide range of interests. He was part owner of Jamestown's first garage. Jamestown's first movie theater grew out of his experience using a movie projector during World War I. He was very involved in the Conanicut Grange and was largely responsible for the building of the Grange hall on West Street.

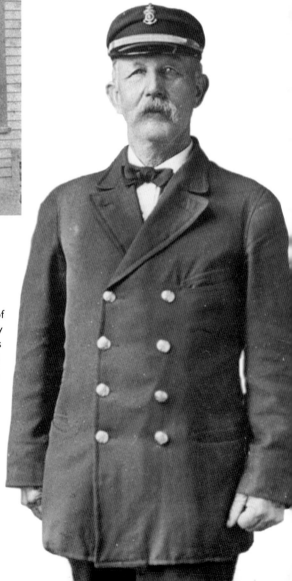

Capt. Peter H. Armbrust
Captain Armbrust, the first of four generations of noted Jamestown citizens, was born in Germany and spent much of his life at sea. The sailing vessels he commanded in the late 19th century carried cargo between ports as distant as Archangel and Buenos Aires. Jamestown was his home port, and for the 20 years before his death in 1916, he captained Jamestown & Newport Ferry Company ferries on the bay.

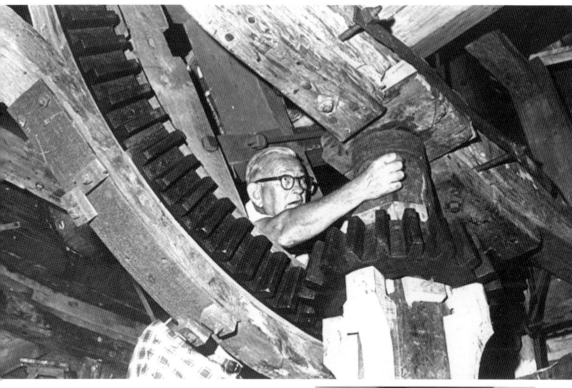

Henry Armbrust
Henry Armbrust, shown here working at the Jamestown windmill, was one of the third generation of Jamestown Armbrusts. An expert in water purification, he held a patent for a "Method for Cleaning a Submerged Surface." With his brother and Manuel Matoes, he founded the short-lived Conanicut Airways. His mother had emigrated from Norway when she was seven, and to remind his grandchildren of their history, he made each a replica of the stool she had brought with her.

Linda Armbrust Warner
Henry Armbrust's daughter Linda has lived in Jamestown her whole life and worked for many years at the Jamestown Post Office. Like her father, she is active in the Jamestown Historical Society and has taken a lead role in preserving the Beavertail lighthouse. (Courtesy of Linda A. Warner.)

Alton Head Sr.
"The Dean of the State's Politicians," as his obituary in the *Newport Daily News* declared in 1958, was a lifelong Republican. He represented Jamestown in the Rhode Island House of Representatives from 1909 to 1911 and then went on to the state senate, where he served continually until 1938. He was a longtime member of the Republican State Central Committee and chairman of the Jamestown Republican Town Committee. (Courtesy of the Head Family.)

Alton Head Jr.
Alton Head Jr. took over his father's seat in the Rhode Island Senate in 1940 and held it until 1958. For a while, he worked for the Jamestown & Newport Ferry Company as quartermaster and purser and was a member of the company's board of directors. A contractor for 20 years, he was particularly proud of his restoration work on the Great Friends Meeting House in Newport in the 1970s. (Courtesy of the Head Family.)

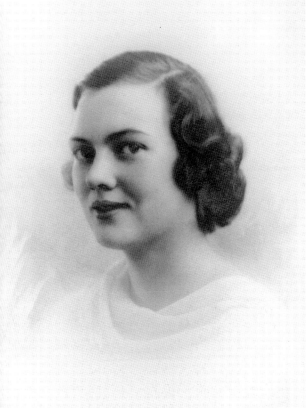

John Edward Brayman
Born in Narragansett, Brayman came to Jamestown sometime in the 1880s. He was primarily a dairyman, selling milk, poultry, and eggs from his farm on North Main Road near the reservoir. He was active in Jamestown politics and served on the town council for several terms, sometimes as its president. His daughter Susan married Lewis W. Hull, who represented Jamestown in the Rhode Island House of Representatives for 24 years.

Caroline Hull Head
Caroline Head, granddaughter of John Brayman and wife of Alton Head Jr., was the Jamestown correspondent for the North Kingstown *Standard Times* for 20 years and for the *Newport Daily News* for 25 years between 1960 and 1985. In her stories and columns, she covered both political and social life in Jamestown. (Courtesy of the Head Family.)

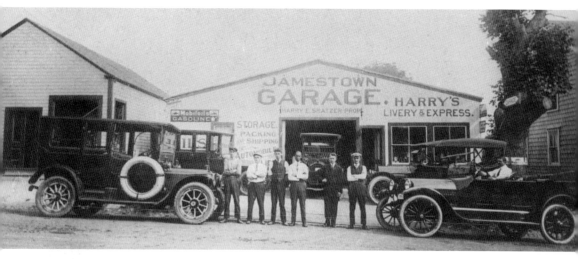

The Molls

Standing in front of the Jamestown Garage on Narragansett Avenue about 1916 are, from left to right, John Moll, Harry E. Shatzer, Charles Moll, Henry Armbrust, and chauffeurs William Youngblood and Jack McKnight. The Molls bought the garage from Shatzer in 1917 and ran it for more than 75 years. Their sister Christina, who helped manage the business, sold the garage in 1992, long after her brothers' deaths.

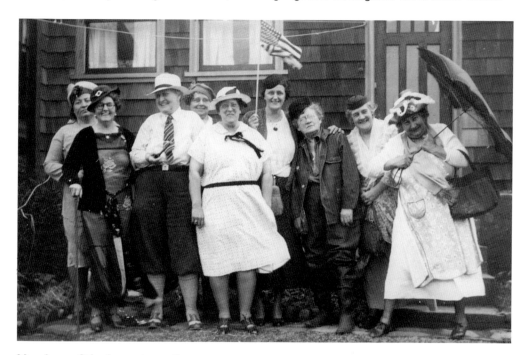

Members of the Jamestown Grange

John Moll married the daughter of Ernest and Margaret Littlefield. Margaret Littlefield, like many Jamestowners, was active in the Grange. Members in costume posing in March 1936 are, from left to right, Jeanette Shelman Tweed, Margaret Thompson Littlefield, Loretta Gosford, Alma Anthony Johnson, Mary Wright Locke, Mrs. Willis Clarke, Amanda Tallman Knowles, Alice Barber Stubbs, and Jennie Barber Tefft. (Courtesy of Norma Moll Walsh.)

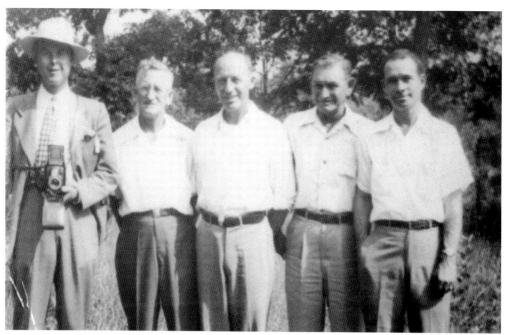

John Elliott Walsh Sr.

Norma Moll's father-in-law, John E. Walsh Sr. (center), was a toll collector on the Jamestown Bridge from 1940 to 1959 and supervising collector from 1959 until 1969, when tolls were removed. He was also deputy chief of the Jamestown Volunteer Fire Department in the 1950s. With him are, from left to right, M. James Vieira, Charles L. Hull, Walsh, Alfred Weeden, and Charles Weeden.

Norma Moll Walsh

John and Alice Moll's daughter Norma was the drum major for the Jamestown Girls Drum and Bugle Corps. In the late 1940s and early 1950s, both the corps and Norma individually won competitions throughout New England. She worked in the office of the Jamestown & Newport Ferry Company for 10 years and at Baker's Pharmacy for 25. (Courtesy of Norma Moll Walsh.)

Walter Lewis Marley

Marley brought his family to Jamestown about 1910 when he took a job at the Naval Torpedo Station on Goat Island in Newport. From 1869 to 1951, all torpedoes for the US Navy were manufactured and tested on Narragansett Bay, and Marley, a foundry molder, helped create molds from which weapon parts were cast. In the late 1920s, perhaps propelled by the post-World War I reduction in munitions spending, he opened Marley's Sea Grill on Narragansett Avenue. The Molls from the Jamestown Garage across the street and owners of other neighboring businesses joined him to celebrate. From left to right are Marley, John Moll, Walter Marley Jr., Alice Moll, unidentified, Christina Moll, unidentified, and Charles A. Benheimer. Marley was custodian of the fire station for many years, as well as special policeman and dog constable. (Courtesy of Margaret Hilton and Norma Moll Walsh.)

Iona Marley Dailey
Marley's daughter Iona left Jamestown after high school to attend nursing school. In 1950, she returned with her husband, William Dailey. They opened the Harbor View Nursing Home in a 60-year-old inn on Conanicus Avenue. When Iona Dailey retired in 1965, her daughter Margaret took over operation of the nursing home and opened a tea room in the Casino next door at the entrance to Shoreby Hill. The Dailey-Hilton family cared for more than 370 people at Harbor View before new regulations forced the nursing home to close in 1975. (Courtesy of Margaret Hilton and Carol Hopkins.)

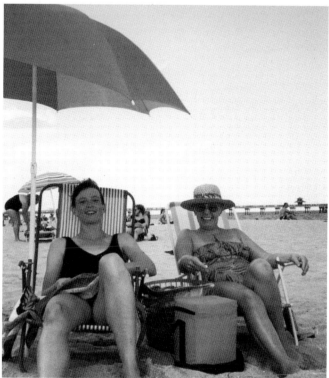

Carol Hopkins and her mother, Margaret Dailey Hilton
Margaret Dailey (right) married a military man, and her four children were born in various places around the world. Carol was born in France and grew up at the Harbor View. She carried trays to the patients, cooked, and ran wheelchair races in the basement. She is now the owner of Island Realty in Jamestown. (Courtesy of Margaret Hilton and Carol Hopkins.)

Donald A. Richardson

Edith's son Donald was born in Jamestown in 1928, because—as he once explained—the ferry didn't run at night. After serving with the Army of Occupation in Japan, Richardson, like many Jamestown residents, worked on the Newport ferry and, when the bridge replaced the ferry in 1969, on the Newport Pell Bridge. He is very active in veterans' affairs and helped renovate the Grange Hall to be used as a senior center. (DHK.)

Edith Caswell Richardson

Edith Caswell, who later married Alfred V. Richardson, graduated from the Jamestown School in 1914 to become one of the first female rural mail carriers in the country. Until the mid-1920s, she traveled by horse and buggy in summer and by horse and sleigh in winter to deliver mail along Jamestown's rural free Delivery Route 1, which had been started about 1906.

Peyton Randolph Hazard

Hazard, who traced his ancestry to colonial Newport, divided his time between Newport and Jamestown and was active in the historical societies of both places. For many years, he wrote witty verses for the *Newport Daily News*. His father, Daniel, built a summer home on Walcott Avenue in 1887, and members of the family lived there for more than 100 years.

Frank H. C. Rice

Rice was the caretaker of the Hazard summer home. According to family lore, Rice saved Daniel Hazard's life when he slipped on rocks while fishing at Beavertail, and Daniel and Daniel's son Peyton felt a lifetime obligation. Frank died in 1937. His wife, Olivia, continued to live in the caretaker cottage behind the house until after Peyton Hazard's death in 1961. Under Peyton's will, Olivia Rice received $100 a month for life, and she moved to a farm she had purchased near the reservoir. (DHK.)

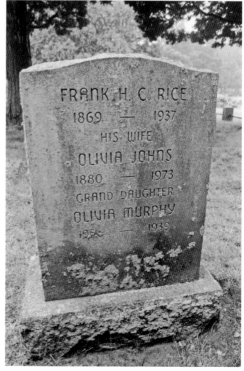

Sergio Francis Andrade

Families of Portuguese extraction began arriving in Jamestown at the end of the 19th century. Many came from the Azores, a mid-Atlantic archipelago of volcanic islands originally settled by the Portuguese in the 16th century. Gardeners and farmers in their homeland, they came to Jamestown to follow the same trades.

Sergio Andrade was one of 13 children who grew up on a small farm on the island of Fayal in the Azores, where they "raised everything" themselves. He followed his older brother and sister to the United States in 1919, shortly before his 19th birthday. He worked in factories in Providence, returning to his island home several times over the next 10 years. In 1930, he came to Jamestown because factory jobs were hard to find in the aftermath of the 1929 stock market crash. At first, he worked building roads in the town. Then, in 1934, he found work as a gardener and caretaker at some of the large summer homes in Jamestown, a service he continued almost 50 years. At 79, he reported that he had a lawn mower to sit on for the big places and a self-propelled mower for small ones: "I work all days on those machines—don't bother me." (Courtesy of the *Providence Sunday Journal*.)

Andrew Lodkey
Lodkey and his wife, Melissa, were born into slavery in Georgia in the 1850s. They came north about 1890, first to New Jersey and then to Newport. When he moved to Jamestown in 1913, Lodkey was 63 years old. He opened a restaurant at East Ferry and catered island events until shortly before his death at age 86. He is shown here as bake master at a Carr family theatrical in 1926.

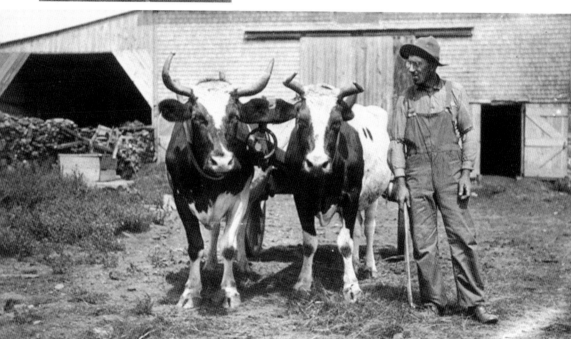

Oliver E. Sprague
Sprague was from Block Island. Primarily a dairy farmer, he lived and worked at the Carr Homestead. He and his oxen, Buck and Duke, were in demand around the island for removing rocks and doing other heavy lifting tasks.

Orville Minkler
Minkler was a recluse who lived in a small house near West Ferry in the mid-20th century. He fed himself mostly with fish he caught from a small skiff, although neighbors often left plates of food on his porch. In return, he built models of the Jamestown ferry boats, fashioned banks like the one shown from tin cans, and occasionally lent a hand with neighborhood building projects. (DHK.)

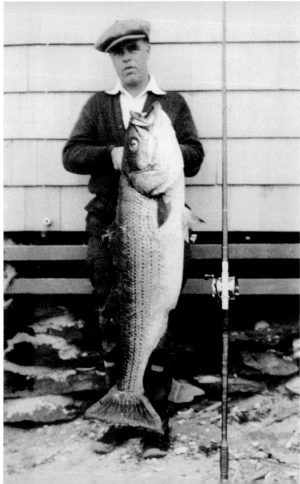

George Barker Jr.
Barker, a painting contractor and for many years the chairman of the town's board of tax assessors, relaxed—like many Jamestown men—by fishing off the rocks at Beavertail. In 1933, he made the local news when he landed a striped bass weighing 48 pounds and measuring 40.5 inches in length.

CHAPTER FOUR

The Resort Era

The Industrial Revolution bypassed Jamestown. The islands didn't begin to feel the effects of this major change in the economy of the country until well after the Civil War, when the increasingly unhealthy environment of the overcrowded cities caused people to look for more comfortable places to pass the summer months, and the accumulated wealth of the industrial giants made it possible.

The first hotel in Jamestown was built in the village by William Hazard Knowles (1819–1906) in 1872. That same year, a consortium led by Lucius D. Davis (1825–1900) and Henry Lippitt (1818–1891) bought 560 acres at the northern tip of Conanicut Island, platted 2,098 house lots for summer homes, and began building the Conanicut Park Hotel. Other hotels and developments followed. Over the next 25 years, farms all around the village were converted into tracts of small and large summer cottages. Ocean Highlands on the Dumplings peninsula was developed by Jamestown citizens led by Frederick N. Cottrell (1835–1884). The last major development, the private enclave of Shoreby Hill on the former Greene farm just north of the town, was the work of a group of men from St. Louis; James Taussig (1840–1921) oversaw the work. While some developers seemed unconcerned about the implications of such rapid growth, others, such as Pardon Tucker (1822–1902), formed companies to provide needed services. Daniel Watson (1837–1899), with offices in both Jamestown and Newport, was the sole agent for most of the late-19th-century developments, including Ocean Highlands and Shoreby Hill.

Narragansett Bay and the activities it offered were the main attraction, and for many years the waterfront was presided over by Abbott Chandler (1850–1909), owner and manager of the boat livery service. Preston E. Peckham (1884–1947) owned a stable on Beavertail, offered buggy rides from East Ferry to the Beavertail Light, and promoted interest in horses and riding.

Architects and builders contributed to the growth of the new resort community. The premier local architect was Charles L. Bevins (1844–1925), who designed more than 40 houses between 1883 and 1889. J.D. Johnston (1849–1928), a Newport resident, was both a builder and an architect. His Clingstone, built on a rocky islet in the East Passage for Joseph Lovering Wharton, still fascinates sailors on the bay. The next generation of architect-builders, such as Louis Wayland Anthony (1856–1943) and T. Remington Wright (1883–1957), built along less grandiose lines than their predecessors.

The resort era ended abruptly with the Great Depression, although the invention of the automobile and airplane, and the ease of travel they brought with them, also contributed to its demise. For a while, the island stagnated, but new builders and developers arrived after World War II, slowly revitalizing the community.

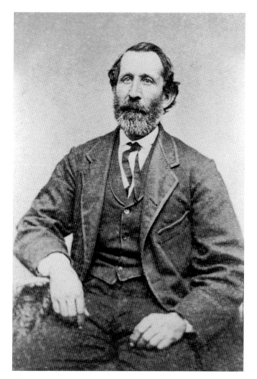

William Hazard Knowles (ABOVE)
Knowles left Jamestown as a young man, looking for larger ventures than the sleepy agricultural community offered. In 1871, he returned and purchased the Jamestown-Newport sail ferry. He promptly raised the rates, an exceedingly unpopular move. The town responded by forming the Jamestown & Newport Ferry Company and putting a steam-driven ferry on the cross-bay run. Deciding that the improved ferry service would bring more and more sophisticated visitors, Knowles built Jamestown's first true hotel, the Bay View.

Capt. Stephen Gardner (RIGHT)
Like Knowles, Gardner combined the professions of ferryman and hotelier. He was the first captain of the steam ferry *Jamestown* when it began its runs between Jamestown and Newport. He and his wife ran a boarding house, called Grove Cottage, on Narragansett Avenue, and in 1883, 10 years after the advent of the steam ferry, he built the Gardner House directly across from the ferry wharf.

Adolphus C. Knowles

Competition between hotels escalated in the 1880s. William Hazard Knowles built the four-story Bay Shore Hotel just west of the Bay View Hotel. The Gardner House added five bays to the existing seven-bay building. In 1889, Newport's Patrick H. Horgan bought land south of the Gardner House and built the Thorndike Hotel. The five-story gabled building could accommodate more than 100 people. The same year, William A. Champlin built his Champlin House, later to become Dr. Bates Sanitarium, on the rise north of the harbor, and James A. Brown floated his nine-bedroom house across the bay from Middletown and opened the Bay Voyage Inn nearby. The following year, an addition more than tripled the inn's capacity. Adolphus Knowles, William Hazard Knowles's son, responded by building an addition to the Bay View Hotel. The new Bay View House was five stories high, and its round tower on the corner of Narragansett and Conanicus Avenues went up five stories more. The tower dominated the ferry wharf, demanding the attention of arriving passengers.

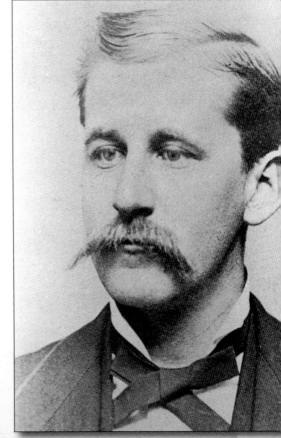

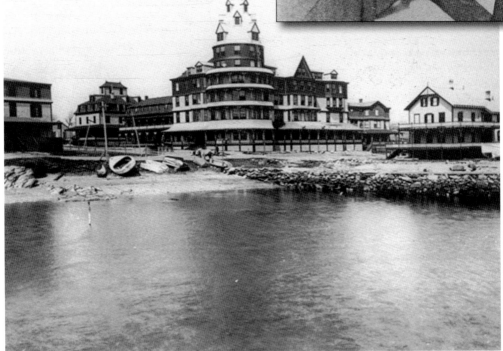

Lucius D. Davis

In 1872, Conanicut Park—a planned development of 2,098 house lots with parks, woodlands, and a common—was laid out on the northern tip of Conanicut Island. Davis, owner of the *Newport Daily News,* was the only developer with local connections. Two years later, a hotel—later expanded to hold 100 guests—was ready for its first visitors. In 1887, contamination of a well that supplied water to the hotel doomed the project.

Gov. Henry Lippitt

The most prominent member of the group that developed Conanicut Park was Henry Lippitt, owner of several textile mills, president of the Rhode Island National Bank, and the governor of Rhode Island from 1875 to 1877. His descendants include several US senators and governors of Rhode Island. In 1889, after the failure of the Conanicut Park development, Lippitt bought the holdings of the company at auction. (Courtesy of Governor Henry Lippitt House Museum, a property of Preserve Rhode Island.)

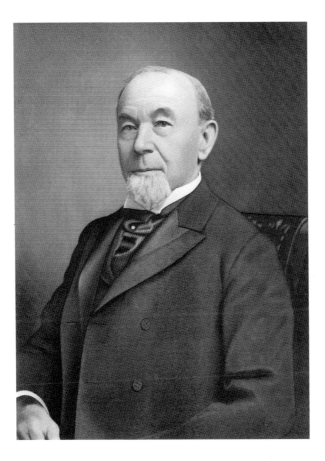

James Taussig

The last major 19th-century development in Jamestown was Shoreby Hill. In 1895, a consortium of men from St. Louis purchased the Greene Farm just north of the village. To transform the farmland into a sophisticated and exclusive vacation enclave, modeled on private "garden suburbs" in St. Louis, the company hired Ernest W. Bowditch, who had recently designed the private community of Tuxedo Park, New York.

The developers invested about $125,000 in infrastructure for the private community. They buried sewer pipes, which were two feet in diameter, to carry raw sewage far out into the bay (a common practice at the time) and laid six-inch water mains. They graded and macadamized streets and built gravel sidewalks.

By September 1896, the construction was far enough along for sales of lots to begin. Lot prices varied with location and view. The lots on Alden Road at the top of the meadow were offered for 35¢ to 40¢ per square foot, or about $6,000 each. Middle-of-the-block lots without a water view could be as inexpensive as 4¢ per square foot. Purchasers were constrained by deed to follow the rules of the planned community. Only one building, costing no less than $3,000, could be built on each lot. It was to be set back at least 20 feet from the road and used exclusively as a private residence. No hedges fronting the road could be higher than 3.5 feet. A covenant, similar to those used by condominiums today, ensured that the roads and other common areas would be maintained.

James Taussig and Ephron Catlin were the managing partners of the Shoreby Hill project, and it was Taussig who was often on the site during its layout and construction and who presented and negotiated development-related matters with the Jamestown Town Council. Taussig was born in Prague and immigrated to St. Louis with the rest of his family following the failed revolution of 1848. He was admitted to the St. Louis bar and soon became one of the city's most prominent lawyers. He built his Shoreby Hill home on Alden Road at the center of the western edge of the Shoreby Hill green. (Courtesy of Missouri History Museum, St. Louis.)

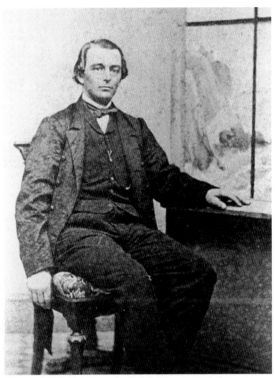

Frederick N. Cottrell
The Cottrell family owned farms on both sides of Mackerel Cove. In 1874, Frederick Cottrell, along with other Jamestown businessmen, organized the Ocean Highlands Company and subdivided 265 acres of the Dumplings area farm into large lots for summer homes. He was also the treasurer of the Conanicut Telegraph and Telephone Company, formed in 1883 in an early and unsuccessful attempt to bring telephone service to Jamestown.

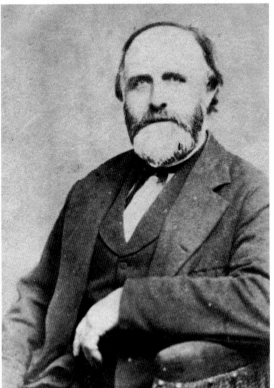

Pardon Tucker
Tucker, who was born in 1822, had already retired from farming when steam ferries made Jamestown an accessible summer retreat, and he had no interest in subdividing his farm just south of the village. Concerned about possible contamination of the water used in the hotels, he helped found the Jamestown Light and Water Company in 1888. Within two years, piped water was available throughout the village center.

Capt. Abbott Chandler

Captain Chandler spent his early life in the merchant marine, making nine voyages around South America to the Pacific Ocean before coming to Jamestown about 1880. He began a small boat business, renting row boats and sail boats from his floating pier south of the East Ferry wharf. He soon expanded into other waterfront activities. He purchased and sold lobsters and clams. He owned and rented out 32 bathing houses along the town beach. In 1887, he built Chandler House, later the Harbor View Inn, on Conanicus Avenue north of Knowles Court to serve as a boardinghouse for seamen. About the same time, the needs of the growing summer population opened a new arena for Chandler, and by the mid-1890s he was acting as caretaker for vacation cottages on the island.

Despite a busy schedule attending to his businesses, Chandler found time to participate in the governance of the town. In 1893, he was elected to two town positions: constable and packer of fish. The town council then appointed him to seven more, all of which would now (if they still existed) be filled by professional staff: truant officer, health officer, inspector of nuisances, inspector of sewers, constable for enforcing liquor laws, bird constable, and special constable. As health officer, inspector of nuisances, and inspector of sewers, he was responsible for enforcing laws—many of them new to what had been until recently a sparsely populated farm community—to ensure the public health. He had to oversee the placement of privies and cesspools within the village. If sewage was piped into the bay, it was his duty to make sure that the drainage pipes extended at least 15 feet beyond the mean low tide mark "or further where necessary so that said pipe shall discharge one foot under water at all times." He was also in charge of the town dump. His constabulary duties were particularly heavy during the summer months, and in July 1899, the town council authorized him as acting chief of police to purchase four night sticks, six badges, and four pairs of twisters (a type of chain handcuffs) "for the use of the police."

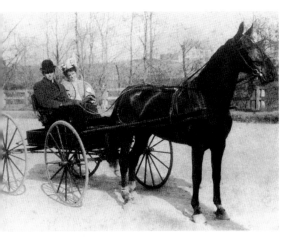

Preston E. Peckham (ABOVE)
One of the more colorful characters among the
developers, Peckham—pictured here with his
wife Katherine—raised homing pigeons from
Belgium, imported and trained horses from
North Dakota, and rode in horse races on
Beavertail Road. He also handled the auction
of land in Bungalow Park at West Ferry and
was town clerk, a member of the town council,
and secretary of the board of directors of the
Jamestown & Newport Ferry Company.

Daniel Watson (RIGHT)
When the first development in Jamestown
village was platted near East Ferry in 1873,
Daniel Watson started his real estate career
as one of the sales agents. He soon became
known as "Real Estate Dan" and, over the next
25 years, was named sole sales agent for every
major Jamestown development south of the
Great Creek, including the elite Shoreby Hill. He
died showing a client a Dumplings site.

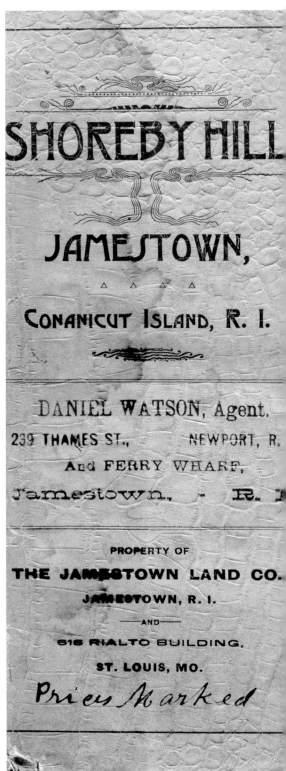

SHOREBY HILL

JAMESTOWN,

CONANICUT ISLAND, R. I.

DANIEL WATSON, Agent.

239 THAMES ST., NEWPORT, R.

And FERRY WHARF,

Jamestown, - R. I

PROPERTY OF

THE JAMESTOWN LAND CO.

JAMESTOWN, R. I.

——AND——

618 RIALTO BUILDING,

ST. LOUIS, MO.

Prices Marked

Charles Lovett Bevins
Bevins was Jamestown's most prolific architect of Shingle Style cottages. Between 1883 and 1899, he designed at least 40 buildings, including many of the large summer houses in the Dumplings and on Walcott Avenue, the Thorndike Hotel, and the first St. Mark church (pictured). He worked closely with Daniel Watson, and no buildings designed by Bevins were built in Jamestown after Watson's death in 1899.

John Dixon Johnston
Although Johnston lived and worked primarily in Newport, the buildings he designed and built in Jamestown, especially Clingstone on its rocky "dumpling" in the East Passage, are emblematic of the summer cottages on the island. (Courtesy of the Newport Historical Society.)

57

Thomas Remington Wright
T. Remington Wright, as he was universally known, was one of three brothers who, following the example of their father, Thomas Downing Wright, were house designers and building contractors. He was the chairman of the Jamestown Bridge Commission during the building of the bridge and, during an inspection tour, posed (far right) with, from left to right, Charles H. Brooks, vice chairman of the commission; Thomas F. Sheehan, president of the Jamestown Town Council; James R. Masterson, assistant secretary-treasurer of the commission; and state senator Harry Fillmore.

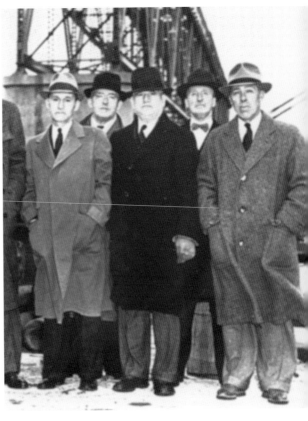

Louis Wayland Anthony
Anthony established the first lumberyard in Jamestown in 1903. He stocked the yard with lumber from woodlands he owned in New Hampshire and used the lumber in his construction business. After his retirement, he grew gladiolas and made a ceremony of delivering them to many of the women of Jamestown. (Courtesy of Adele Anthony.)

CHAPTER FIVE

Summer Visitors

By 1900, Jamestown's year-round population of 1,000 swelled to more than 3,500 in the summer months. Many summer residents, such as Joseph Wharton (1826–1909) and his sons-in-law Joshua Bertram Lippincott (1857–1940) and Harrison S. Morris (1856–1948), came from Philadelphia. Most of the Philadelphians built their summer homes in Ocean Highlands on the Dumplings peninsula although some lived on Beavertail.

The Providence summer people settled in Conanicut Park at the North End. Charles Fletcher (1839–1907) built the imposing Point View on the northeast shore. Jeanie Lippitt Weeden (1852–1940) lived in the cozier Victorian Stonewall Cottage close by. The cottage was later the home of Pamela Mitchell (1922–2002).

Retired Navy officers, less concerned about the proximity of relatives and fellow townsmen, found accommodations around the village. One of the first to arrive was Civil War hero Adm. David Dixon Porter (1813–1891), who built a house at High Street and Walcott Avenue, away from the bustle of the ferry wharf but convenient to the village. Other military personnel followed until they formed a sizeable contingent in the summer community.

While the younger men often traveled back and forth to their businesses, the women and children usually stayed for the whole summer. Some women built cottages of their own. Encouraged by her Boston employer Alexander Agassiz, who had his summer laboratory at Castle Hill in Newport, Elizabeth Clark (1855–1932) hired Charles L. Bevins to design Half-Acre on lower Walcott Avenue in 1895. Jeannette Shivers Heap Sharrer (1852–1901), a Navy widow and niece of Admiral Porter, built in the less prestigious West Ferry area in 1896 on land she had purchased nine years earlier.

Many of the families summered in Jamestown for several generations. They took a proprietary interest in the town, although at times their ideas clashed with the needs of the winter community. Children who spent their summers on the island considered themselves a special kind of Jamestowner, and many have returned as full-time residents.

The Wharton Family

Two Wharton brothers, Charles and Joseph, bought property in the Ocean Highlands area of Jamestown in 1882. Both men were Quakers from Philadelphia with ancestral ties to Newport. They were married to two sisters, Mary and Anna Lovering.

Charles, the elder brother, built his summer home, Braecluegh, on land that is now part of Fort Wetherill State Park. When the federal government tore the house down to make way for the fort, Charles's son built Clingstone, also known as the House on the Rock, on a large islet off the Conanicut Island coast in the East Passage. Joseph built his cottage, Horsehead, further west on the point at the eastern entry to Mackerel Cove. Clingstone and Horsehead are still landmarks for sailors entering Narragansett Bay.

In 1904, Joseph Wharton's family gathered to celebrate Joseph and Anna's 50th wedding anniversary. From left to right are (first row) their son-in-law Harrison S. Morris, grandson J. Bertram Lippincott, granddaughter Catharine Morris (Wright), and grandson Joseph Wharton Lippincott; (second row) daughter Joanna Wharton Lippincott, granddaughter Marianna Lippincott (O'Neill), Anna Lovering Wharton, Joseph Wharton, and granddaughter Sarah Lippincott (Biddle); (third row) daughter Anna Wharton Morris, son-in-law J. Bertram Lippincott, and daughter Mary Lovering Wharton, who never married. (Courtesy of Harrison M. Wright.)

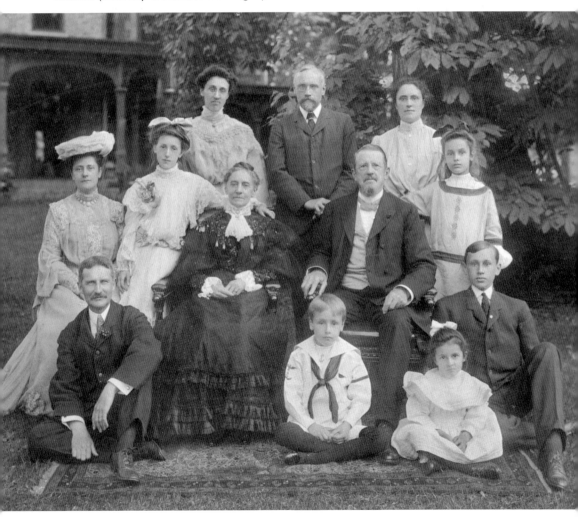

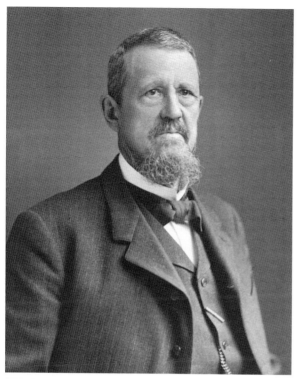

Joseph Wharton
Wharton was an industrialist and philanthropist who cofounded the Bethlehem Steel Company, founded the Wharton School at the University of Pennsylvania, and was one of the founders of Swarthmore College. He and his family summered at Horsehead, which is named for a rock formation on the cliffs below the house. Some of his descendants now make Jamestown their home. (Courtesy of Harrison M. Wright.)

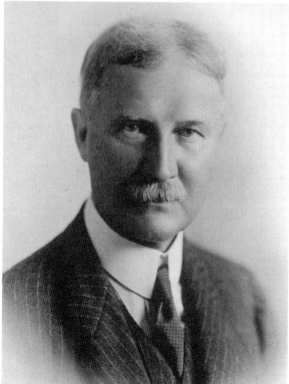

Harrison S. Morris
Morris was one of this country's first professional arts administrators. A magazine editor and writer of fiction, poetry, and biography, he was also director of the Pennsylvania Academy of the Fine Arts from 1892 to 1905 and president of the Art Association of Newport (now the Newport Art Museum) from 1916 to 1947. (Courtesy of Harrison M. Wright.)

Charles Fletcher

Fletcher was born in England and spent years learning the English textile industry before he immigrated to Rhode Island in the late 1860s. Once here, he built a regional empire for the production of woolen cloth and consolidated his holdings into the American Woolen Company. An ardent yachtsman, he sailed his steam yacht, *Emu*, from his waterfront estate in Conanicut Park at the North End.

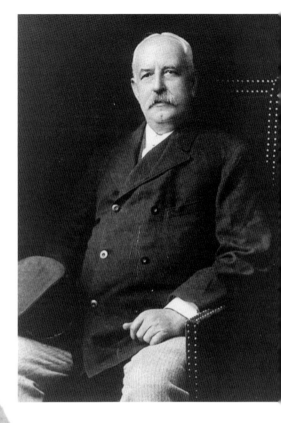

Jeanie Lippitt Weeden

Jeanie Lippitt, daughter of Gov. Henry Lippitt, lost her hearing after contracting scarlet fever when she was four. In defiance of then current teaching of the deaf, Jeanie's mother taught her to lip read and speak. Her speech was refined by instruction from Alexander Graham Bell. Jeanie's successful communication skills ultimately led to the establishment of the Rhode Island School for the Deaf in 1876. She married William Babcock Weeden in 1893. (Courtesy of Governor Henry Lippitt House Museum, a property of Preserve Rhode Island.)

John T. Scheepers
Scheepers, a Dutch immigrant, was widely known as the "Tulip King," both because of his achievement in popularizing the tulip as the symbol of spring and because of his success in developing new varieties of the flower. Scheepers and his wife, Rose, summered in Jamestown at a cottage built for them on Fox Hill Farm, which was owned by Rose's brother-in-law Benjamin Cottrell. (Courtesy of John Scheepers Beauty from Bulbs and the family of Jan S. Ohms.)

Jeannette Shivers Heap Sharrer
Like many Navy wives in the late 19th century, Sharrer lived in Newport while her husband was at sea. She was fond of taking the ferry to Jamestown and walking to West Ferry to watch the sunsets and, in 1887, bought land on the shore north of the ferry wharf. Nine years later, after her husband's death, she built Jamestown's first portable cottage there. Her descendants still summer on her land. (Courtesy of the Daggett Family.)

Elizabeth H. Clark
Clark built Half-Acre on Walcott Avenue in the mid-1890s. The large house was designed to accommodate the four young children that her brother had left with her after his wife's death. As personal assistant to the naturalist Alexander Agassiz, whose summer laboratory was in Newport, Clark was responsible for his zoological interests during his frequent absences. When Agassiz died in 1910, he left her $25,000 plus $5,000 a year for life.

Adm. David Dixon Porter
Among the earliest naval officers to retire to Jamestown was Admiral Porter, who rose to fame in the Civil War. Later, he was superintendent of the US Naval Academy and became, in 1870, only the second person to have the rank of admiral. He told a town council meeting that Jamestown was "the healthiest and pleasantest place he had found in all his travels." (Courtesy of the Library of Congress, Prints & Photographs Division, Civil War Photographs, LC-B813- 1334.)

The First Admirals' Tea

"It is said," reported Maud Howe Elliot in *This Was My Newport*, published in 1944, "that if, on Conanicut Island, you closed your eyes and threw a stone you would probably hit a retired Rear Admiral." The popularity of the town as a retirement home for military officers is testified to by the annual Admirals' Tea, which was held each summer from 1924 to 1939.

The tradition of Admirals' Tea was started by Rear Adm. Colby M. Chester, who invited the admirals in the area to his home to commemorate the 60th anniversary of the Civil War Battle of Mobile Bay, an action in which he had participated shortly after his graduation from the US Naval Academy. Chester was noteworthy as the only naval officer who saw active service in the Civil War, the Spanish-American War, and World War I.

On August 5, 1924, fourteen retired US Navy and Marine Corps flag officers gathered for the celebration. From left to right are (first row) Rear Adm. Yates Stirling, Rear Adm. George C. Remey, Rear Adm. George H. Wadleigh, and Rear Adm. Theodore F. Jewell; (second row) Rear Adm. William T. Swinburne, Rear Adm. Spencer S. Wood, Rear Adm. Colby M. Chester, Adm. Albert Gleaves, and Rear Adm. Newton E. Mason; (third row) Maj. Gen. George F. Elliott (USMC), Rear Adm. Warner B. Bayley, Rear Adm. Joseph L. Jayne, Rear Adm. Bradley A. Fiske, and Rear Adm. Reginald F. Nicholson.

The following year, the admirals were invited to the Calvert Place home of Mary Remey Wadleigh, the daughter of Rear Admiral Remey and daughter-in-law of Rear Admiral Wadleigh, to celebrate her father's birthday. Mary Wadleigh continued to host the event for a couple of years after her father's death in 1928.

In 1930, Rear Adm. Spencer S. Wood, the youngest of the admirals to attend the 1924 Admirals' Tea, took over the tradition and moved the party to his home on Westwood Road, near the West Ferry. During the 1930s, the party expanded so that one guest at the celebration in 1939, the last before Wood's death in 1940, counted 32 admirals and other Navy officers.

While Wood entertained the old guard, a new generation of naval officers was learning about Jamestown as they trained in Newport and sailed with the Atlantic fleet out of Narragansett Bay. For them, the transition to peaceful life in Jamestown had to wait until after World War II.

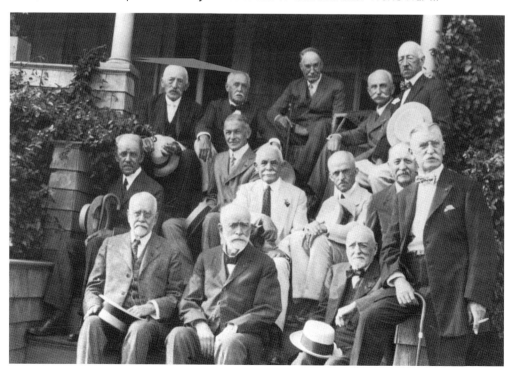

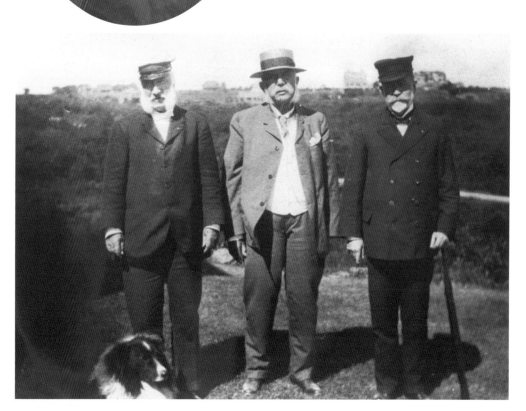

Rear Adm. George C. Remey

Remey spent 13 months in a Confederate prison after he was captured in early September 1863 while leading an attack to regain Fort Sumter. In 1900, he was in the Pacific as commander in chief of US naval forces in Asiatic waters during the Boxer Uprising in China. For many years, from the turn of the century through the 1920s, the Remey family summered in Jamestown hotels.

Rear Admirals Thomas O. Selfridge Sr. and Jr.

In 1903, Thomas O. Selfridge Sr. (left), then 97 years old, visited his son Thomas O. Selfridge Jr. (center) who summered at the Barnacle, a Shingle Style cottage overlooking the East Passage. During the Civil War, the younger Selfridge briefly commanded an experimental submarine torpedo boat and later served at Newport's torpedo station. With them is Rear Adm. George C. Remey.

Rear Adm. Spencer S. Wood
Wood commanded the battleship USS *Oklahoma* in World War I and was later in charge of the First Naval District, which included Rhode Island. Wood may be the only admiral to have a song written in his honor; in 1918, Chief Yeoman Daisy May Pratt Erd published the song the "Rear Admiral Wood One-Step." Wood built a house at West Ferry, where a grandson still lives.

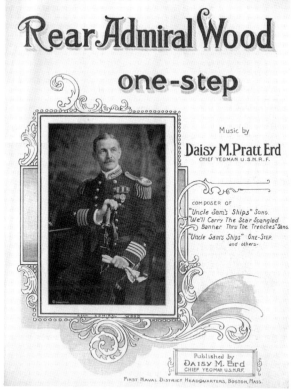

Vice Adm. Joseph K. Taussig
Joseph K. Taussig was a second-generation summer Jamestown resident. His father, Rear Adm. Edward D. Taussig, served in the Pacific during the Spanish-American War before retiring to Jamestown in 1908. The younger Taussig was an outspoken critic of the country's lack of preparation for war with Japan and was reprimanded for testifying to Congress in April 1940 that war in the Pacific was inevitable. The reprimand was rescinded December 8, 1941.

The three sisters

Emma, Marion & Alice

Happy 80th Birthday

Pamela W. Mitchell

Marion Mitchell

Pamela Mitchell

Pamela Mitchell was the adopted daughter of the youngest of three unmarried sisters who, along with their mother, Emily K. Mitchell, began summering in Jamestown in 1915. Mitchell was an adventurous young woman who lived much of her life in New York and Paris. When she was in her early 30s, she was sent to Paris to negotiate the rights for the American premiere of Samuel Beckett's *Waiting for Godot*. For 17 years after their initial meeting, she corresponded with the Irish playwright. Mitchell retired to Jamestown in her late fifties. As her 80th birthday approached, knowing that she was near death from cancer, she determined to give herself one final birthday party. The poster with pictures of herself with her mother and aunts in Jamestown was created for the occasion. She had to leave the party early and died on her way back to her room in February 2002.

CHAPTER SIX

Our Healthy Shores

In 1881, the *Newport Daily News* stated boldly, "Jamestown is a healthy place with the rate of mortality less than in any other town in the state." Dr. William Lincoln Bates (1855–1932), a member of the Carr family, established his sanitarium, also called Maplewood, in 1900. The sanitarium was part resort, part health spa, and part nursing home for the chronically ill. At its nursing school, young women trained to care for the patients.

Despite a deadly fire in 1931, the facility remained open until 1944. Early physicians on the island worked closely with Dr. Bates and used Maplewood's surgery and maternity services. Between 1915 and 1935, at least 136 Jamestown babies were born at the sanitarium. Then and later, others were born at home, helped into the world by midwife Susan Stillman (1886–1976).

During the summer months, when the population of the island more than doubled, the number of physicians more than doubled, too. Doctors in all specialties, many of them from the Philadelphia area, summered in Jamestown. A few, like Dr. David B. Birney (1862–1906), had an active summer practice; others, like the surgeon Dr. George B. McClellan (1849–1913), were on call when their special services were needed. After 1918, Dr. Henry Ecroyd (1858–1937) maintained a year-round office in Jamestown.

Since the mid-20th century, Jamestown has had one and usually two full-time doctors with offices on the island. Dr. Charles Barrus Ceppi (1911–1983) practiced on the island from the 1940s to the early 1970s. In 1984, Dr. Joseph J. England (1955–) started the Jamestown Family Practice. The first dentist to establish a full-time practice was Dr. Nathan Anthony Estes (1920–1984) in 1959.

The Jamestown chapter of the Red Cross, founded in 1932, organized a motor corps in 1941 under the direction of Lenore McLeish (1899–1981), using her station wagon as its first ambulance. One of the earliest volunteers was Mary Rose Neronha (1906–2000). The organization became the Jamestown Emergency Medical Service and is now a part of the Jamestown Volunteer Fire Department.

Thomas E. Hunt (1883–1965), a Newport pharmacist, opened his pharmacy in what is now called the Hunt Block in 1929. The drugstore stayed in the same building at the corner of Conanicus and Narragansett Avenues, under different owners, until 1983. Timothy Baker (1952–) opened Baker's Pharmacy on Narragansett Avenue in 1977 and moved to a much larger building in 1987.

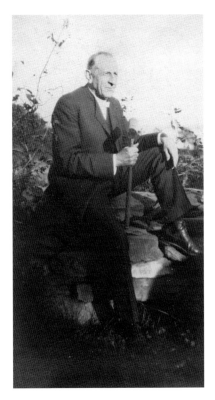

William Lincoln Bates, MD

Dr. Bates was a practitioner of electrotherapy. An asterisk after his name in the directories of the American Medical Association indicated that he had not attended medical school but practiced under the portion of Rhode Island's 1895 law regulating medical practice that allowed doctors who were already established to continue their practice. Dr. Bates, who had spent time in Jamestown as a child, first brought his practice to Conanicut Island during the summer of 1897. He was so enthusiastic about the healthful effects of island air that in 1899 he established a summer sanitarium at the North End.

The following year, Dr. Bates moved his sanitarium to the rapidly developing village area. He rented, and later purchased, the Cory farmhouse on Conanicus Avenue. The sanitarium expanded to Maplewood, a hotel built by William A. Champlin in 1890, and he added a small village of tents and then tiny bungalows. The Cory barn was converted into quarters to house 15 male patients and orderlies in 1927. The building burned to the ground in a disastrous fire in 1931. Five people—four patients and orderly Joseph Hardimen, who had heroically returned to the burning building to lead the men to safety—died.

The Cory farmhouse had a surgical ward and housed the patients in need of most care. From 1915 through 1935, the sanitarium had a maternity department. At least 136 babies were born there, approximately 21 percent of the 648 births recorded in the town during the period. The Maplewood part of the sanitarium differed little from the resort hotels except that Dr. Bates stressed the idea of healthy living. The complex included a working farm that produced much of the food consumed by the patients and staff. The farm supplied meat, poultry, and eggs. The cream and milk were from the farm's dairy herd. Vegetables and fruits were grown, harvested, and preserved.

Dr. Bates was a member of many local organizations, including the Jamestown Board of Trade (a civic organization similar to a chamber of commerce), the Religious Society of Friends (Quakers), and the Jamestown Historical Society, for which he wrote the original bylaws and which he served as president for many years. During World War I, the sanitarium offered the Red Cross the use of five free beds and the sanitarium ambulance. It also provided hospital services during the influenza epidemic that followed the war, although the facilities were not usually used to treat infectious diseases.

Bates's Babies

Nine of the people born at Dr. Bates's Sanitarium, and one who delivered a baby there, gathered to celebrate the opening of an exhibit about the sanitarium in 2000. They are, from left to right, Manuel Neronha Jr., born 1929; Roselyn Guimarey (Fraley), born 1929; Victor Richardson, born 1924; Donald A. Richardson, born 1928; Barbara Smith (Wilcox), born 1929; William E. Clarke, born 1926; Lillian Pemantel Dutra; Joseph William Chesbro, born1920; Shirley Tiexiera (Quattromani), born 1930; and Jane Chesbro (Clarke), born 1927. (Courtesy of the *Standard Times,* photograph by Ray Clayton, December 28, 2000.)

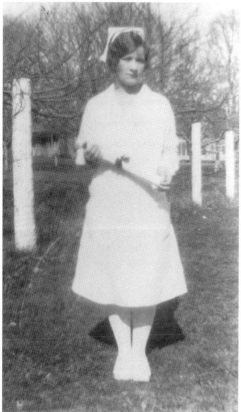

Ethel Cadorette Tiexiera

Tiexiera entered Dr. Bates's Sanitarium Nursing School for attendant nurses at Maplewood in 1928. During the 18-month training period, she learned general patient care, bandaging, massage, and how to calm down excited patients. She also met her husband and moved permanently to Jamestown, where she worked as a nurse at the sanitarium and for Dr. Henry Ecroyd. Some of her descendants still live on the island. (Courtesy of Linda S. Clarke.)

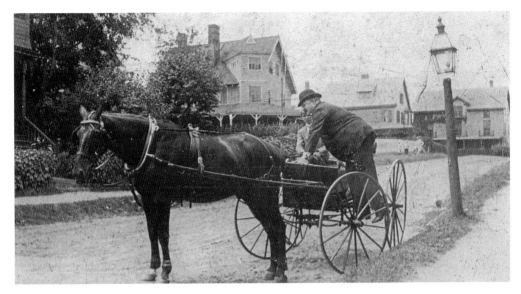

David Bell Birney, MD

Dr. Birney had an active summer practice in Jamestown from his house on Union Street. He also supported efforts to increase the town's popularity as a summer resort. A golf enthusiast when golf in the United States was in its infancy, Dr. Birney organized the Jamestown Golf and Country Club in 1901. He joined the Jamestown Improvement Society, which sponsored the annual Jamestown Day parade and worked to improve the look of the village. When he died unexpectedly as a result of an automobile accident in 1906, the Improvement Society had a memorial stone inserted in the new wall in front of the Gardner House. Dr. Birney came from a distinguished family. His grandfather, James B. Birney, had twice run for president on the Liberty Party ticket. His father, Gen. David Bell Birney Sr., commanded the Union Third Corps, First Division, at Gettysburg. He married May Rebecca Lane in 1896. (Courtesy of Frank W. Birney.)

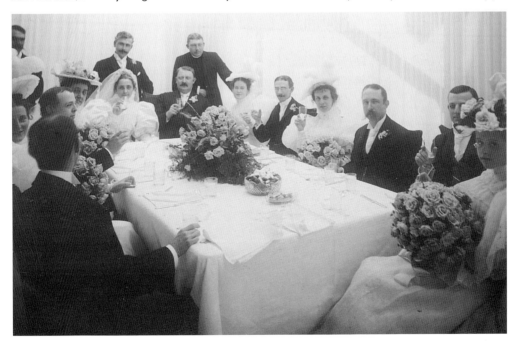

George B. McClellan, MD
Dr. McClellan, one of the most distinguished medical visitors to Jamestown, was professor of anatomy at the Pennsylvania Academy of the Fine Arts and the Jefferson Medical College in Philadelphia. With Dr. Henry James Rhett, he founded the Quononoquott Club, a private club for people who lived in the Friendship Street area. (Courtesy of Archives & Special Collections, Thomas Jefferson University, Philadelphia.)

Henry Ecroyd, MD
Dr. Ecroyd was 60 years old when he opened his office at 32 Narragansett Avenue in 1918. His earlier practice had been in Newport and in Muncy, Pennsylvania, and he was already well known in Jamestown. For almost 20 years, he took care of Jamestown patients and was, for a time, the school doctor. (Courtesy of Manuel Neronha Jr.)

John Allan Sweet, MD, the Last of the Bonesetting Sweets

Before the mid-19th century, what is now called orthopedics was not studied in medical schools nor covered in the medical apprenticeships that trained many doctors. Instead, bonesetters realigned broken bones and returned dislocated joints to their proper position. While some bonesetters were charlatans, as were some "doctors" before Rhode Island passed its first laws regulating medical practice in 1895, others came from families in which the knowledge of the skeleton and its musculature and an understanding of how to manipulate them were passed down from father to son. Such was the Sweet family, which arrived in Rhode Island from Wales in 1637 and for nine generations practiced bone setting in southern Rhode Island.

Before the late 19th century, the Sweets did not consider bone setting a vocation, and most of them worked as masons, blacksmiths, or carpenters. Their charges for bone setting were based on time lost at their primary occupation and expenses incurred. In one story told about William (1802–1888), a seventh-generation Sweet, it is related that he felt bad about charging $8 for a trip to Newport that, because of the weather, had entailed an overnight stay in Jamestown and another in Newport.

The later Sweets were attracted to Jamestown for the fishing. William's son Jonathan (1838–1925) was a professional fisherman who lived on the west shore south of Dutch Island Harbor and made his medical skills available to the Jamestown farmers. Jonathan's grandnephew John H. Sweet Jr. (1874–1933) had a fishing camp at Beavertail, where he and his father, John H. Sweet Sr. (1850–1913), relaxed from their medical work. In the 20th century, the Sweets found that if they were going to practice the family profession they had to obtain medical degrees. John H. Jr. graduated from Harvard Medical School in 1898. His son John Allan Sweet (1908–1964), who practiced in Jamestown for a short period before moving to Florida in 1952, followed in his father's footstep. (Courtesy of the Newport Historical Society.)

Charles Barrus Ceppi, MD
Dr. Ceppi had his office in his home on Narragansett Avenue for 35 years, from 1941 to 1976. His practice took him to South County Hospital in Wakefield and to Newport Hospital. In the days before the Newport Pell Bridge opened in 1969, he would often catch a much-needed cat nap on the East Passage ferry. (Courtesy of the Ceppi Family.)

Susan Stillman
Stillman, on the far right with the tape measure around her neck, was Jamestown's midwife in the 1930s and 1940s. Sewing for American servicemen at the Army Mother's Club at Fort Getty during World War II are, starting at left around the table, Alma Johnson, Ellen Toomey, Hazel or Clara Didsbury, Stillman, Mildred Brooks, and Mary Matoes Sheehan.

Joseph J. England, MD
Dr. England opened the Jamestown Family Practice, which is connected with Newport Hospital, in 1984. His humanitarian efforts have included trips to Central America with Volunteer Optometric Services to Humanity and leadership of the local Red Cross chapter and the Jamestown Medical Fund. An amateur saxophonist, he was the driving force behind the creation of the Jamestown Community Band in 1993 and plays with his own group, Forty Steps, at community affairs. (DHK.)

Nathan Anthony Estes, DDS
Dr. Estes, the first dentist to establish a practice in Jamestown, had an office in his home on High Street from 1959 until 1973. A member of the Jamestown School Committee, he chaired the school building committee during the construction of the Lawn Avenue School. (Courtesy of Jane Estes Bentley.)

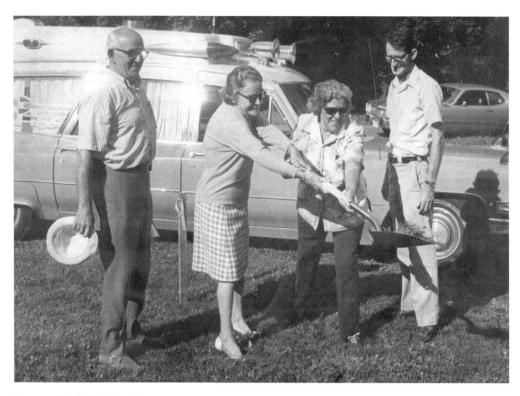

Lenore McCall McLeish

McLeish, shown here at the ground-breaking for the Knowles Court Ambulance Garage in 1974, founded the local Red Cross motor corps in 1941. She was a summer Jamestown resident from Philadelphia who recorded her four-year battle against mental illness in a memoir *Between Us and the Dark*. Shown here are, from left to right, John C. Rembijas; McLeish; Mary Rose Neronha; and William R. McCarthy, commander of the Jamestown Ambulance Association.

Mary Rose Piva Neronha

Neronha (center, with Elma Dollar and Cheryl Serpa) came to Jamestown from the Azores as a child. In the early 1940s, she joined with Lenore McLeish to form what would become the all-volunteer Emergency Medical Services Division of the Jamestown Fire Department. She was the first recipient of the Jamestown Business and Professional Women's Club "Woman of the Year" award in 1974.

Thomas E. Hunt
Hunt had had a summer pharmacy in Jamestown for five years when, in 1934, he moved to the island to open the town's first year-round drugstore. He held many town positions, including chairmanship of the planning board and the school committee. Hunt (far right) is shown here with other members of the school committee (from left to right) Manuel Matoes, Helen Foley, and Mary O'Connor.

Timothy Baker
Baker's Pharmacy on Narragansett Avenue is one of only about 30 independent pharmacies in Rhode Island. Baker, who opened the pharmacy in 1977, is convinced that the people of Jamestown profit from that independence because he knows and cares about the people he serves and about their community. Through the Jamestown Chamber of Commerce and previous village business groups, he has worked to promote cooperation among the small businesses in town. (DHK.)

CHAPTER SEVEN

The Business of Business

The economics of a resort community, and more recently a suburban village, are very different from the economics of farming. New skills were needed to deal with the new realities.

One of the first new occupations to appear was that of real estate agent. Daniel Watson (page 56) led the way. Albert W. Luther (1843–1907), a grocery store owner from Newport, established a real estate office at the East Ferry wharf in 1887. William H. Severance (1858–1925) took over the firm in 1912. When Severance became ill, LeRoy Meredith (1884–1958), who had worked for Severance for several years, bought the company with the help of Archibald Clarke (1869–1933), who added insurance to its offerings. The firm of Meredith & Clarke was a fixture in A.W. Luther's old office on the East Ferry wharf until 2011.

Other services followed. Most of them were established near East Ferry. Herbert Hammond (1876–1957) opened a hardware store. Samuel Smith (1834–1932) grew flowers in his huge greenhouses and sold them both in Jamestown and beyond. Ernest Vieira Jr. (1890–1932) bought a van to drive goods from the ferries to stores and homes, and the Clarkes, a father-and-son team, supplied water, coal, and ice. Lyons Market, run for many years by Thomas J. Lyons Jr. (1887–1964), was one of several small groceries, and Westall's, under the charge of Charles Westall (1884–1960), was known throughout the state for its homemade ice cream.

The town's resort base eroded with the Great Depression and World War II, and new business ideas took root. William Munger (1948–) began developing the harbor as a destination marina in 1974. Architect William Burgin (1946–) uses some of the features of late-19th-century Shingle Style cottages in new buildings to integrate them into the character of the village. The building trades remain, supporting the renewed growth of the town.

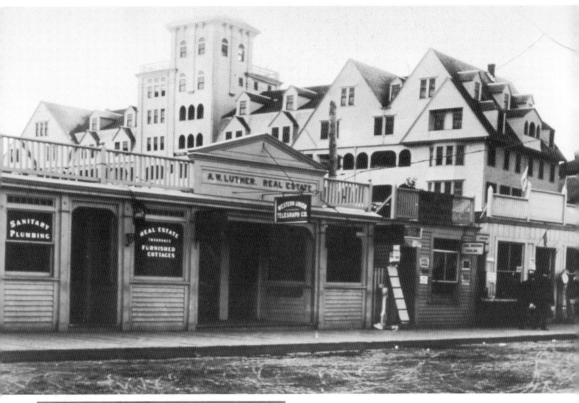

Albert W. Luther
Luther's wife was a Cottrell who had inherited land platted as part of the Ocean Highlands development. The plots were selling very slowly, and Luther started his real estate business at the East Ferry in Jamestown in 1887 in a successful effort to promote Jamestown as a summer resort. He was a director and, for a time, the managing director of the Jamestown & Newport Ferry Company.

William H. Severance
Severance had two farms: the Severance homestead farm on the northeast corner of Eldred Avenue and North Main Road and another nearby on the west side of North Main Road. Severance purchased Luther's real estate business in 1912 and focused on summer rentals. He was elected Jamestown Town Clerk in 1908 and was reelected every year until his death in 1925. (Courtesy of David Lawrence Grinnell.)

LeRoy F. Meredith and Archibald M. Clarke
Neither Meredith (above) nor Clarke (right) was born in Jamestown, but each married a Jamestown woman. Meredith was working at William Severance's real estate business when Severance took ill in 1924. He wanted to buy the business, and because he did not have the capital, he approached Clarke to fund the needed $1,500. Clarke had recently sold his interest in a profitable grocery store chain in Connecticut. He was only 54 and was, perhaps, bored with retirement. The two men bought out Severance and formed the firm of Meredith & Clarke. Knowing that Meredith did not need help with the real estate side, Clarke built the insurance agency branch of the firm. Both men were also active in the community. At the time of his death in 1933, Clarke was president of the Jamestown & Newport Ferry Company and a member of the school committee. Meredith served as secretary-treasurer of the Jamestown Bridge Commission.

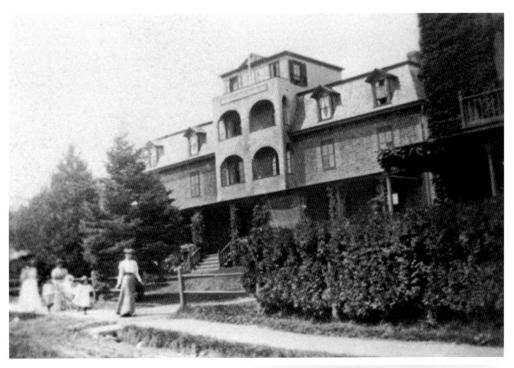

Charles E. Weeden

Charles E. Weeden was the direct descendant of William Weeden, one of the original purchasers of Conanicut Island. Primarily a hotelier, he owned Prospect House (pictured), a small inn on Green Lane, in the late 1880s. In 1891, he leased the much larger Thorndike Hotel, which he managed for the next 10 years, before entering the real estate business. He was purser and later manager of the Jamestown & Newport Ferry Company.

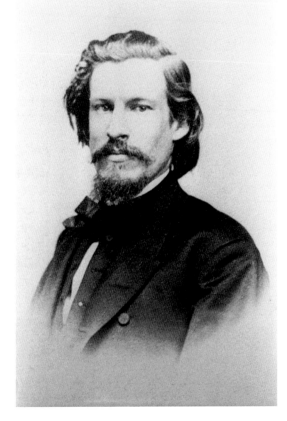

Thomas Hartwell Clarke

Clarke was a devoted educator. He taught for many years in the Newport grammar schools. From 1873 to 1882, he was superintendent of the public schools of Newport, and from 1883 to 1898 he was superintendent of schools in Jamestown. The Thomas H. Clarke School, built in 1923, four years after his death, was named for him.

Isaac Clarke

In 1887, Isaac Clarke, a descendant of Joseph Clarke, one of the original purchasers of Jamestown, dammed and deepened a pond on his land on Southwest Avenue to capture water from a local spring. He bottled and sold water from the spring. During the winter, he cut ice from the pond and stored it in sawdust for summer sale. In 1890, his pond became the town's first reservoir. (Courtesy of Arthur S. Clarke III.)

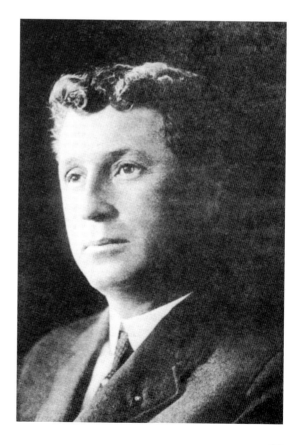

Isaac Howard Clarke

Isaac Howard Clarke, Isaac Clarke's son, owned and operated the Jamestown Coal Company and, later, a contracting and building business. He held almost every local elective office available. He was state representative in 1907–08 and state senator from 1909 to 1911. He was a school janitor, town clerk, member of the school committee, and director of the Jamestown & Newport Ferry Company— all, at the time, elective offices. (Courtesy of Arthur S. Clarke III.)

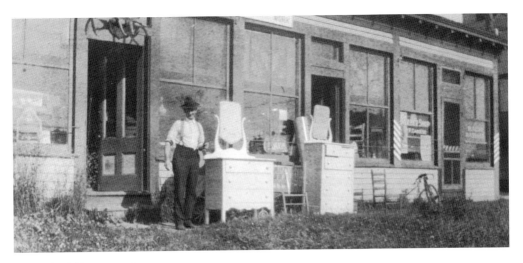

Herbert F. Hammond

Like many turn-of-the-century Jamestown residents, Hammond was multitalented. He painted houses, handcrafted furniture, and bought and sold antiques from his shop on Conanicus Avenue. In 1929, he opened Hammond's Hardware at 5 Narragansett Avenue. His hardware store is still there, now known as Jamestown True Value Hardware. (Courtesy of Alice Hammond Dunn.)

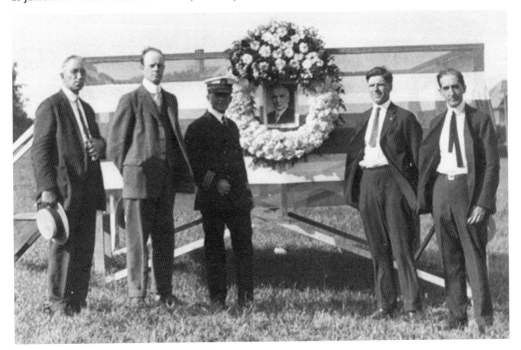

Charles A. Hayward

Hayward owned Hayward's Paper Store at East Ferry and was an officer of the Conanicut Land Improvement Association, which developed the plat bordered by Conanicus Avenue, Bay View Drive, and Mount Hope Avenue. He is pictured (far right) with other members of the Jamestown Town Council at the memorial for Pres. Warren G. Harding in 1923. They are, from left to right, Adolphus C. Knowles, Samuel W. Smith Jr., John Daniels, and John L. Smith.

Jamestown Businessmen of 1928

By the early part of the 20th century, the area around the East Ferry wharf, where the Jamestown-Newport ferryboats docked, had established itself as the center of commerce for the community. A 1960 calendar issued by the E.R. Vieira Company featured two photographs taken in January 1928 by John L. Smith, owner of Samuel Smith and Sons Wholesale Florist and Smith's Flower and Gift Shop, a block from the ferry wharf on Narragansett Avenue. The caption below the photographs on the original calendar read, "Dedicated To The Above Men For Their Contribution To The Welfare Of Jamestown, Rhode Island."

The men featured in the January 13 photograph are, from left to right, Archibald M. Clarke, cofounder of Meredith & Clarke, a real estate and insurance company; Charles A. Hayward, the owner of Hayward's Store; LeRoy F. Meredith, cofounder of Meredith & Clarke; Harry Pitchers, owner of Pitchers Drug Store; Norman F. Caswell, owner of Caswell's Express; Isaac H. Clarke, owner of the Jamestown Coal Company; Herbert F. Hammond, founder of Hammond's Hardware Store; Perry H. Brown, a steamboat police officer for the Jamestown & Newport Ferry Company; Herbert Barlow, manager of the Jamestown office of J.T. O'Connell Hardware and Lumber Store; Vernon A. Head, a local taxicab operator; and Ernest R. Vieira Jr., founder of E.R. Vieira Company.

Posing for the photograph taken on January 12 but absent the next day were Charles A. Benheimer, the owner of Benheimer's, a variety store; Charles H. Brooks, manager of the Jamestown & Newport Ferry Company and later manager of the Jamestown Bridge; Job Howard Ellis, owner of Ellis's Restaurant; Robert T. Mathewson, a Jamestown constable; and Jesse C. Tefft, a longtime associate in the office of the Jamestown & Newport Ferry Company and chief of the Jamestown Volunteer Fire Department.

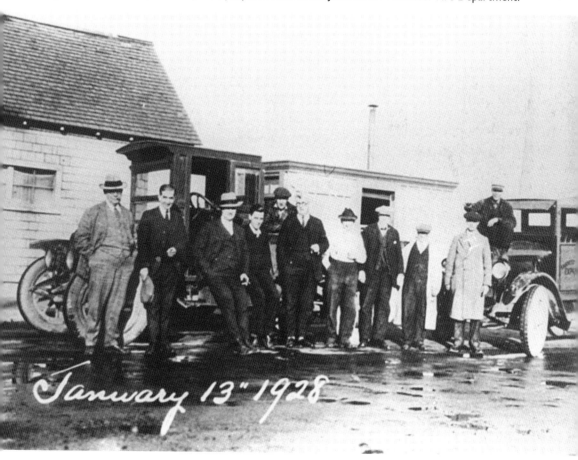

Thomas W. Lyons Jr.

During World War I, Lyons (left, with an unidentified butcher) served on the battleship *Rhode Island* and volunteered for the submarine service. When he returned home, he worked with his father at Thomas W. Lyons and Son grocery store on Narragansett Avenue near Green Lane. The elder Lyons died in 1928; Lyons and Son remained in business under the son's management until 1955.

Charles Westall

Westall started peddling his ice cream, originally made with a hand-cranked machine in a shed near the family home, in 1918. In 1929, he opened a store on Narragansett Avenue that had ice cream equipment with a capacity of 1,000 quarts. Westall (third from left) posed with Bertha Donelly and two unidentified customers at his Saunderstown store, which he opened in 1948. (Courtesy of the Westall Family.)

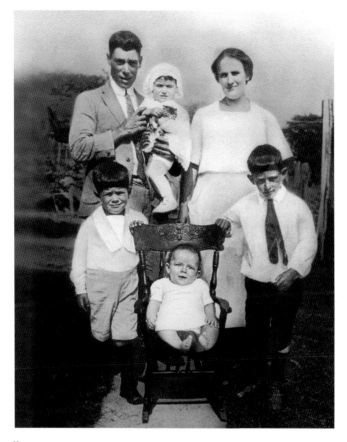

The Vieira Family

Ernest R. Vieira Jr. was born in the Azores, as was his wife, Louise Rose, whom he met in Providence soon after his arrival in the United States in 1910. The couple married in 1915 and settled in Jamestown. In 1922, Vieira bought a Reo Speedwagon and started an express business, moving luggage for summer visitors and delivering freight from the ferries to local stores. He quickly expanded into coal delivery. The E.R. Vieira Company was doing well.

On October 18, 1932, Vieira and some friends went fishing off the rocks at Horsehead. A wave swept all four men into the water and three drowned, including Vieira. He was 42 years old. He left behind his wife, sons Ernest, 15, and Alfred, 13, and a daughter, Mary, 10. Louise was five months pregnant with his third son, George.

Louise and the two boys were determined to keep the business going. With the help of Manuel Guimarey, who had worked part time for Vieira and was made a full-time member of the team, they did. The company expanded into the ice and distilled water businesses. When oil replaced coal for home heating and as fuel for the ferry, they added oil delivery and oil furnace installation and maintenance. The company maintained the Jamestown Bridge from 1959 to 1969 under a series of annual contracts with the town's Jamestown Bridge Commission.

Each family member took responsibility for a portion of the growing business: Ernest III was in charge of the bridge maintenance and similar contracts with the town; Alfred oversaw the oil business; Mary kept the books. George joined the firm in the mid-1950s.

This family photograph, taken about 1923, shows the family as it never was. In the rear is Ernest Vieira Jr. holding Mary with Louise next to him. In the front are Alfred and Ernest III with baby George pasted in on the chair between them. George was born about nine years after the picture was taken. (Courtesy of Mary Vieira Ragland.)

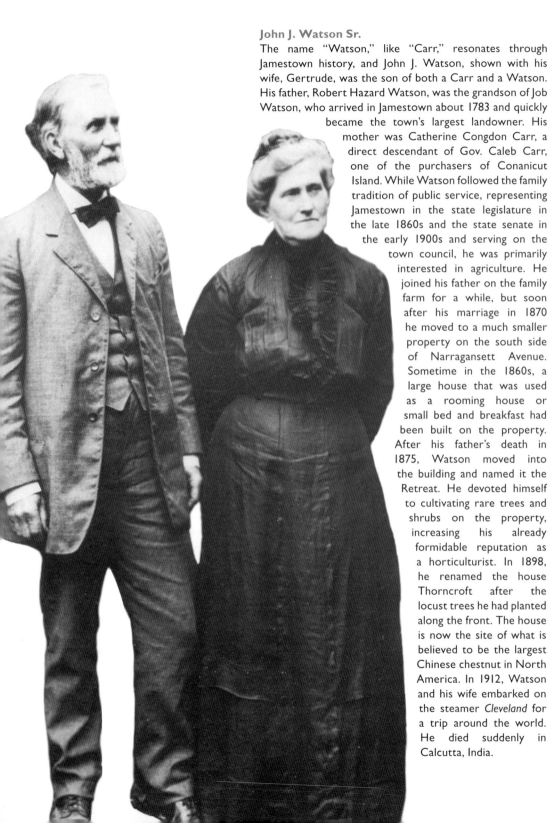

John J. Watson Sr.

The name "Watson," like "Carr," resonates through Jamestown history, and John J. Watson, shown with his wife, Gertrude, was the son of both a Carr and a Watson. His father, Robert Hazard Watson, was the grandson of Job Watson, who arrived in Jamestown about 1783 and quickly became the town's largest landowner. His mother was Catherine Congdon Carr, a direct descendant of Gov. Caleb Carr, one of the purchasers of Conanicut Island. While Watson followed the family tradition of public service, representing Jamestown in the state legislature in the late 1860s and the state senate in the early 1900s and serving on the town council, he was primarily interested in agriculture. He joined his father on the family farm for a while, but soon after his marriage in 1870 he moved to a much smaller property on the south side of Narragansett Avenue. Sometime in the 1860s, a large house that was used as a rooming house or small bed and breakfast had been built on the property. After his father's death in 1875, Watson moved into the building and named it the Retreat. He devoted himself to cultivating rare trees and shrubs on the property, increasing his already formidable reputation as a horticulturist. In 1898, he renamed the house Thorncroft after the locust trees he had planted along the front. The house is now the site of what is believed to be the largest Chinese chestnut in North America. In 1912, Watson and his wife embarked on the steamer *Cleveland* for a trip around the world. He died suddenly in Calcutta, India.

Samuel and Bridget Smith

Samuel Smith, who died in 1932 at 97 years of age, was born in England and immigrated to Georgia in 1853. He acquired a plantation on the St. Johns River in Florida and seemed to have been doing well there when the American Civil War began in April 1861. He came north to avoid the war and settled in Newport.

He and a partner, Michael Butler, erected greenhouses on Bellevue Avenue and began a florist business that catered to the social elite who summered in Rhode Island. They also opened a branch in New York, one of only five florist shops in the city at the time. According to family lore—which considering his 10 years in the South seems possible—Smith introduced the gardenia to the florist industry. Although the partnership dissolved in 1880, Smith's florist business continued. He had moved to Jamestown in 1870 and built greenhouses behind his house on Narragansett Avenue, from which he supplied florist shops in Boston, Providence, and Newport. The 3,200 square feet of glass enclosing his greenhouses rated a special note in the state report on agriculture in Jamestown in 1885. Smith continued in the florist business until about 10 years before his death, when his sons took over the business.

Smith's first wife, Margaret, died in the early 1880s, and in 1883 he married 19-year-old Bridget Murphy, who was 30 years his junior. Together they had eight children, two of whom, Samuel Jr. and John L., became important figures in 20th-century Jamestown. Bridget, who was known as Delia, was one of the founders of St. Mark Catholic Church in Jamestown. She also owned and ran the Bay Shore Hotel on Narragansett Avenue between her husband's florist shop and the Bay View Hotel.

Smith, a lifelong Democrat in then-Republican Jamestown, ran for the Rhode Island Senate in 1893. He received more votes than anyone else, but not a majority of the votes cast and so was not elected. Nonetheless, he remained active in local politics, and he passed his political convictions on to his son John, who was one of the founders of the Democratic Party in Jamestown.

Frank Pemantel

Frank and Isabel Pemantel operated the North End Bargain Center for 40 years, from 1958—before zoning regulations restricted retail sales to the village—until Frank's death in 1998. The store at the corner of Summit Avenue and North Main Road contained a wealth of junk with an occasional gem to be unearthed.

Albert A. Boone

In 1890, Samuel Smith brought his 18-year-old nephew Albert Boone over from England to help with his growing business. Boone built a reputation as a landscape gardener and, in the 1930s, took over management of Shoreby Hill estates. He also was elected to the town council, the school committee, and, from 1920 to 1923, the state senate.

William Munger
Munger, a Jamestown native, and his wife, May, started their marina business at East Ferry in 1974 with 10 guest moorings. In 2013, the business employed more than 50 people, many of whom are Jamestown craftsmen who can repair, maintain, and refit both power and sailing vessels. During the summer, the marina's piers and moorings are visible reminders of Jamestown's increased popularity as a yachting destination. In winter months, activity moves to a 10-acre facility at Taylor Point. (DHK.)

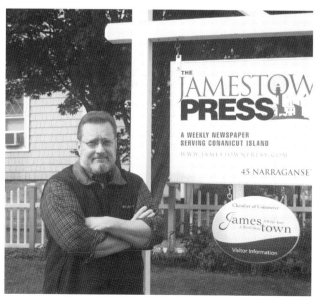

Jeffrey McDonough
McDonough purchased the weekly *Jamestown Press* in 1991. As publisher and, in the early days, editor of the paper, he ensures that the people of Jamestown know what is happening in their town. Since his arrival, he has worked to encourage cooperation among village businesses and has been an advocate for the growth of local commerce in Jamestown. (DHK)

William Burgin

Soon after Burgin came to Jamestown in 1974, he restored the 1829 Isaac Carr general store on Narragansett Avenue. This and other local architectural projects, along with 15 years on the board of the Jamestown Historical Society, implanted an understanding of the history and character of the town. His award-winning designs for the Jamestown Police Station (1991) and Jamestown Town Hall (2007) demonstrated his ability to express the town's character in its public buildings. (Courtesy of William Burgin.)

Arthur S. Clarke III

Clarke, known to his friends as Archie, is a descendant of one of the original purchasers of Conanicut Island. He operates his excavation business from the lot where his great-grandfather Isaac once sold spring water and ice. History, especially the history of the Jamestown ferryboats, is his avocation, and he has an unparalleled collection of photographs and memorabilia of the ferry days, including the wheelhouse of the ferryboat *Hammonton,* which he restored. (DHK.)

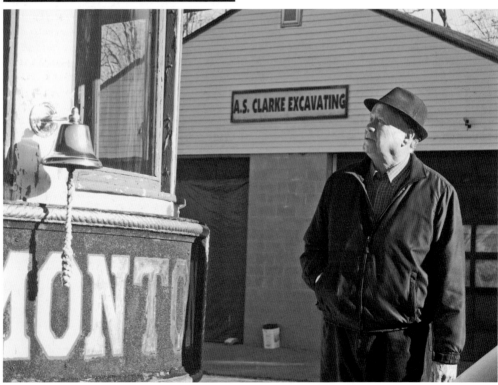

CHAPTER EIGHT

Leaders and Protectors

In the 19th century, most of the leaders in Jamestown were members of a few families with large farms on the island. The Carrs, Watsons, and Caswells took their responsibilities seriously, working hard to keep their small community of about 120 closely related families running smoothly. The 20th century brought major changes. The population increased by 20 percent every 10 years. New needs and new leaders arose. One of the earliest signs of change was the organization of a formal volunteer fire department in 1890. Many men led the department over the next 125 years; the two who were fire chief the longest were Jesse C. Tefft (1883–1957) and Merton C. Hull (1899–1973). Valmont (1928–) and Kenneth (1957–) Caswell, father and son, volunteered young, following the Caswell family tradition of service. The town council also established a police department, although without state authorization, in 1890. Three police chiefs—Charles Edward Hull (1869–1946), Chester Green (1888–1967), and James G. Pemantell (1938–)—were charged with keeping the peace on the island for 70 of the next 100 years. Education was always a priority, and the superintendents of schools and chairs of the board of education, such as Anthony J. Miller (1909–1995) and Linnea Olson Petersen (1946–) played important roles.

New political leaders arose. John L. Smith (1897–1988) organized a local Democratic Party in all-Republican Jamestown in the early 1920s. Democrat Dr. Albert B. Gobeille (1919–1997) was the town council president in the 1950s when Commerce Oil proposed to build an oil refinery at the North End. One of the most controversial figures involved in Commerce Oil's plans was Jamestown lawyer Daniel J. Murray (1910–1998). Mary Stearns McGaughan (1915–1997) documented the divisive battle. In the midst of the uproar, the town celebrated its 300th anniversary in 1957 with an elaborate celebration planned by John L. Smith and Martha Greig (1919–1994). A new town charter in 1974 moved the conduct of the town's day-to-day business to the control of professional administrators. Rosamond Tefft (1913–1994) and Robert Sutton (1942–) were among the first appointees under the new charter.

Preserving the island's history began early in the 20th century when Mary Rosengarten (1847–1913) collected money to buy the derelict Jamestown windmill. With the fight against the refinery, awareness of the need to protect the environment increased—fueled by the work of William Miner (1908–1992). For many, saving history and the environment became intertwined. Thomas Carr Watson Jr. (1897–1979) left his 19th-century farm to the Society for the Preservation of New England Antiquities (now Historic New England) to save both the farmland and the way of life it represented; Donald (1951–) and Heather (1951–) Minto protect his legacy. Edwin W. Connelly (1926–2001) and Betty Hubbard (1935–), too, found that saving the artifacts of the past helps to shield the environment.

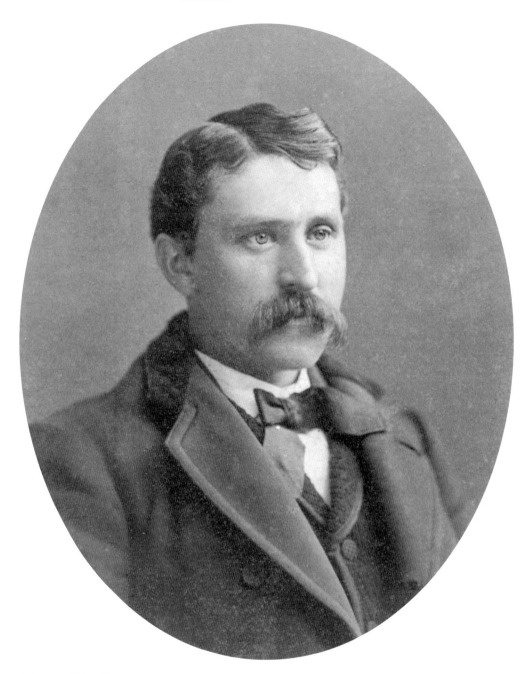

Thomas Giles Carr
Carr, a middle son, left Jamestown soon after the end of the Civil War and traveled to South Carolina to try his hand at growing cotton. After two years, he returned to Jamestown and settled down to raise sheep on the 70-acre Knowles farm. The Grange, an organization that was designed to help farmers both financially and socially at a time when agriculture no longer seemed central to the American way of life, came to Jamestown in 1889. Carr was a charter member and later an officer of the Conanicut Grange. Like most of the Carrs, he was active in public life. He was school superintendent for 10 years and tax assessor for 20. He was also elected to the state house of representatives for three terms and the senate for two.

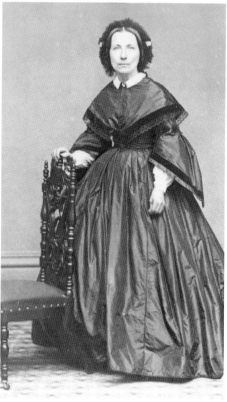

John E. Watson and Mary Watson
Until the current town charter was adopted in 1974, the position of town clerk was elective. John E. Watson was elected town clerk in every election from 1844 until his death in 1882. Since Jamestown had no official town hall (the first town hall was built in 1883) Watson conducted town business out of his home at the corner of Narragansett and Clinton Avenues. For a time, the same building housed the US Post Office. Jamestown's first postmaster was appointed in 1847, and for many years the post office moved with the postmaster. Mary J. Watson, John E. Watson's wife, was postmistress from 1880 to 1888.

Thomas Carr Watson Sr.

Thomas Carr Watson, like his ancestors on both the Carr and Watson sides, was very active in town and state politics. He was only 25 when, in 1863, he was first elected to represent Jamestown in the Rhode Island House of Representatives, a post he held for 22 years. He was also president of the town council and a director of the Jamestown & Newport Ferry Company.

William Field Caswell

When Caswell was postmaster in Jamestown, the office was a political appointment. Franklin D. Roosevelt made it a civil service position on July 22, 1936. A staunch Republican, Caswell was appointed and reappointed by presidents Taft, Harding, Coolidge, and Hoover, although his final appointment was not confirmed when Roosevelt took office. He was also town moderator for many years. (Courtesy of F.C. Caswell.)

Albert B. Gobeille, MD

Dr. Gobeille was president of the Jamestown Town Council during one of the most contentious periods of Jamestown's history. He was elected in 1954, and among his first initiatives was the adoption of a health code, the first of its kind on the island. Jamestown's financial picture was bleak. The reduction of military personnel at the island's four forts meant less money was flowing into its economy; at the same time, the land used for the forts could not be returned to the tax rolls. The ferry system, which had been losing money since 1932, was leased to the state in 1951, but the state refused to take on the town-owned company's $250,000 debt. Dr. Gobeille was determined to reverse the situation without raising taxes. In early 1956, Commerce Oil, acting for Gulf Oil, presented plans to build an 800-acre oil refinery north of Carr Lane. Dr. Gobeille backed the plan, feeling that the economic benefits outweighed the potential hazards. After a special financial town meeting showed that 70 percent of Jamestown voters agreed with him, the Gobeille-led town council amended the zoning ordinance to establish a refinery use district and issued a license to Commerce Oil to operate in September 1956. The Jamestown Protective Association, led by Dr. William Miner (page 112), was organized to fight the plan. The following May, Dr. Gobeille was reelected to the town council along with four other pro-refinery candidates. The defeat did not deter the refinery's opponents, and they attacked the refinery and the town's zoning ordinance in court. The conflict ended in 1960 when Gulf Oil withdrew its support of the refinery, but the hard feelings it generated divided the town for many years.

In the middle of the divisive battle over the refinery, Jamestown celebrated the 300th anniversary of the purchase of Conanicut and Dutch Islands from the Narragansett. More than 1,000 people attended the opening ceremonies on August 10, 1957. As president of the town council, Dr. Gobeille (pictured left with state representative Harold Shippee) presided over the ceremonies.

After leaving the council, Gobeille continued to work to relieve Jamestown of the debt incurred by the Jamestown & Newport Ferry Company. As president of the Jamestown Bridge Commission, he obtained a court decision that required the state to provide severance pay to ferry employees, and he presided over the termination of the commission when the state took over the Jamestown Bridge in 1969.

Daniel J. Murray
Murray favored the refinery and was spokesperson for a pro-refinery citizens' committee. In 1956, as attorney for Commerce Oil, he applied for and received the necessary licensing for the refinery. In 1957, he was named solicitor for the town, an appointment that enraged refinery opponents, and he represented both clients throughout the controversy. In 1980, when Commerce Oil asked for a zoning change to build a 300-unit condominium on the land originally purchased for the refinery, he presented their plans to the town council.

Mary Stearns McGaughan
Mary McGaughan and her husband, Terrence, were members of the Jamestown Protective Association, which opposed the refinery. In 1994, McGaughan wrote the story of that opposition in *Dismissed with Prejudice: the epic battle against construction of an oil refinery in Jamestown, Rhode Island*. An early environmentalist, she founded the Humane Society of Jamestown and developed an educational program about animals for third-graders. As a founding member of the Friends of the Jamestown Library, McGaughan successfully advocated the building of a new library on North Road in 1971. (Courtesy of David S. Martin, her son.)

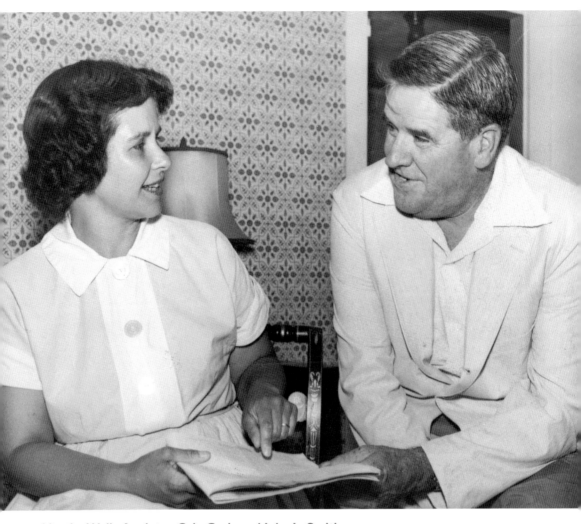

Martha Wylly Appleton Cain Greig and John L. Smith
From August 10 to August 17, 1957, Jamestown celebrated the 300th anniversary of the purchase of Conanicut and Dutch Islands from the Narragansett. The two people most responsible for the gala celebration were cochairs John Smith and Martha Greig. Smith was a founder of Jamestown's Democrat Party. A member of the town council in the 1920s and 1930s, he was its president for five terms, including 1939 and 1940, when the Jamestown Bridge was being built. As chairman of the Jamestown Bridge Dedication Committee, he organized the three-day bridge opening celebration. Greig, almost 20 years Smith's junior, was a Republican and, in the midst of the tercentenary preparations, found time to campaign for school committee. An early member of the Jamestown Ambulance Association, she was an occasional correspondent to the *Providence Journal*, the *Newport Daily News*, and the *Wickford Standard Times*.

Marguerite Elliott Eddy

Eddy (center), a parade adjutant in the tercentenary parade, was photographed with Martha Greig (page 99), cochair of the celebration, and Dr. Albert Gobeille (page 97), town council president. In 1958, she was the first women to run for a seat on the Jamestown Town Council. She graduated from Vassar in 1914 and did graduate work in bacteriology at Columbia, Brown, and New York Universities and at the Marine Biological Laboratory at Woods Hole, Massachusetts. She worked as a bacteriologist in the Newport Health Department from 1921 to 1956 and was Jamestown Health Officer from 1931 to 1937.

Mary Tapper Tollefson

Every town needs a gadfly, someone who attends all meetings, has comments on everything, and questions the status quo. In the mid-20th century in Jamestown, "That woman," as she labeled herself in a response to a newspaper column criticizing her approach, was Tollefson.

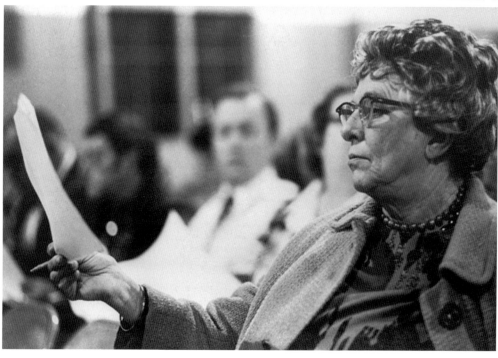

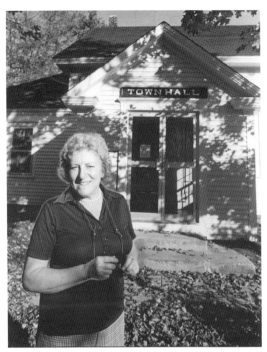

Rosamond Tefft

When the town clerk's position was an elected position, Tefft out-polled her opponents every election from 1955 to 1973. Many years there were no opponents. When the town charter making the town clerk an appointed position was adopted in 1974, she was appointed to the position and continued in the post five more years.

Robert W. Sutton

Sutton helped write Jamestown's Home Rule Charter, adopted in 1974, and was the first town administrator under the charter. His conviction that strong individual leadership should be combined with collaborative thinking ensured the orderly establishment of a robust administrative organization. Since 1992, he has focused his energies on protecting the environment, working for many years for the Rhode Island Department of Environmental Management. He started Jamestown's community farm in 2000.

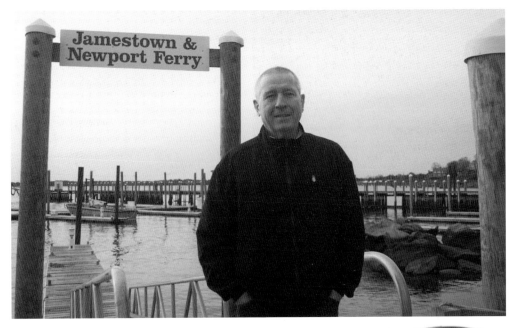

John A. Murphy

Attorney Murphy is enthusiastic about island life and about helping others enjoy it. Jamestown's many nonprofit organizations, from the recently minted Jamestown Arts Center to the 100-year-old Jamestown Historical Society, have profited from his pro bono legal support. His book *Murphy was a Lawyer . . . and a Quahogger* captures the lighter side of the law with thoughtful quotes illustrated with cartoons by Don Bousquet. (DHK.)

Fred Forrest Pease

Town sergeant Pease is a former Jamestown Town Council president and the current deputy director of Jamestown's Emergency Management Agency. In addition to being the captain of a research vessel in the University of Rhode Island's Department of Ocean Engineering and a Jamestown Fire Department volunteer, tuba-playing Pease is a founding member of the Jamestown Community Band. (DHK.)

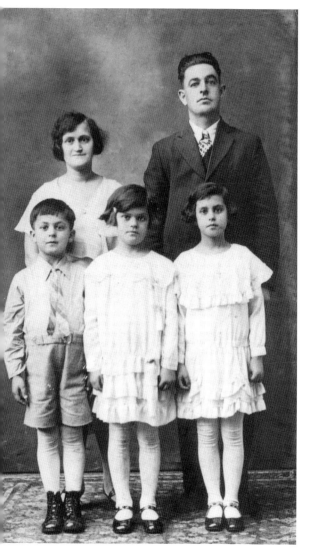

Frank S. Furtado
The Jamestown chapter of the Holy Ghost Society, a social and spiritual organization that has its roots in Portugal, was established in 1924, when a large number of first- and second-generation Portuguese lived in Jamestown. Furtado, who had grown up on the island, was a charter member. He worked as a landscape gardener most of his life, was the town's highway superintendent, and was the first town council member of Portuguese descent. (Courtesy of the Furtado Family.)

Edward F. Morinho
Morinho enlisted in the US Army Air Forces in 1942 and served as crew chief and flight engineer during World War II. After the war, he was an active member of the Holy Ghost Society, doing everything from serving beer at Holy Ghost Hall to refereeing basketball games. He served on the town council in the 1950s and 1970s, was the longtime training officer of the Fire Department, was the town's civil defense director, and spent a decade as campground supervisor at Fort Getty. (Courtesy of the *Jamestown Press*.)

The Clarke Sisters

Lena, Sarah Jane (known as Jennie), Clara, and Mary were the daughters of Thomas H. Clarke (page 82), superintendent of Jamestown schools from 1883 to 1898. Only Mary married. Lena, Jennie, and Clara each made her own way. Lena attended Harvard night school and taught in the Jamestown schools for 42 years, starting in 1895. She was the first president of the Jamestown Historical Society in 1912. Shown in the above picture from the early 1920s are, from left to right (first row) Lena, Nellie Hammond Bivins, Martha Cottrell Clarke; and Isabelle Hull; (second row) Edna Hammond, Mary Clarke Hammond, Abbie Tefft, and Robie Caswell. Jennie (below, with Clara on hay rake) started working for the telephone company in Providence around 1903. When Jamestown got a year-round switchboard in 1916, she was appointed supervisor and then chief operator, a position she held until her retirement in 1944. Like Lena, she was an acknowledged expert on Jamestown history. Clara was the bookkeeper at the Jamestown Garage for many years and assistant librarian at the Jamestown Philomenian Library.

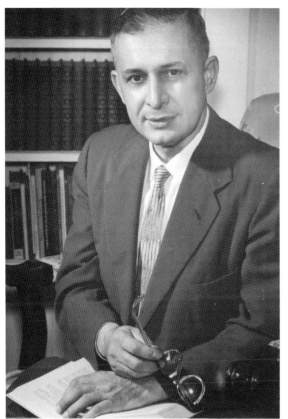

Anthony J. Miller
Miller, usually called Pat, taught at the Thomas H. Clarke School from 1934 until 1944, when he was appointed superintendent of Jamestown schools. He was superintendent during the planning for and building of the Lawn Avenue School, which opened in 1955. He resigned in 1962.

Linnea Olson Petersen
Petersen, photographed with her grandson Michael and the gown in which four generations of her family have been christened, grew up in Jamestown knowing the importance of community involvement. When she was four, her mother was elected tax collector for "God's Country," as she called Jamestown. Petersen served on the board of the Jamestown Historical Society for over 30 years. During her 12 years as chair of the Jamestown School Committee, she oversaw the construction of the Melrose Avenue elementary school. (DHK.)

Jesse C. Tefft and Merton C. Hull

The Jamestown Fire Department is an all-volunteer organization. The town council appointed Henry L. Smith to organize the department in December 1890. In January, volunteers assembled and formed one engine and one hose company. A hook-and-ladder company was formed the following week. James W. Oxx was elected the first fire chief in 1892. After a major hotel fire in 1894, the town council authorized the purchase of a horse-drawn steam engine. The LaFrance steam pumper, *Tashtassuck No. 1*, that was purchased is now in the fire department museum. The fire station, completed in February 1928, is still in use after an expansion from three to five bays and the addition of a second floor.

The two longest-serving fire department chiefs were Jesse C. Tefft, center, who was fire chief from 1912 to 1915 and again from 1930 to 1945, and Merton C. Hull, right, who was chief from 1945 to 1965. With them is John Elliott Walsh Sr., deputy fire chief under Hull. The ax was presented to Tefft on the occasion of his retirement from the department.

Both Tefft and Hull grew up in Jamestown. Unusual for the day, Tefft went to college and was the quarterback of the University of Rhode Island (then the Rhode Island College of Mechanical and Agricultural Arts) football team for its first three seasons in the 1890s. He graduated in 1895 and returned to run the Jamestown windmill with his brother. After he and his brother closed the mill in 1896 because they could not compete with the flood of roller-ground cornmeal from the Midwest, he worked for the Jamestown & Newport Ferry Company, first on the repair crew and, after serving in the Navy in World War I, as the chief clerk.

Hull was a carpenter and house builder. He planned, designed, and built the original Firemen's Memorial on the corner of Narragansett Avenue and Coronado Street in 1958. The building has since been expanded to become the Jamestown Fire Department Memorial Museum. (Courtesy of the Jamestown Fire Department Memorial Museum.)

Valmont Caswell
In his mid-teens, Caswell, universally known as Bucky, attended fire department training sessions and, when a driver agreed, rode along on calls. He volunteered officially as soon as the department allowed—at the first meeting after his 21st birthday. His specialty was the town's fire-alarm system, which he installed with the help of Dalton Brownell. In 2013, after 64 years of service, he became the longest-serving volunteer in the department's 125-year history. (Courtesy of the Jamestown Fire Department Memorial Museum.)

Kenneth Caswell
One of Kenneth Caswell's grandfathers ran the steam pumper *Tashtassuck No. 1* in the 1900s; the other was fire chief in the 1940s. Following family tradition, Caswell volunteered for the fire department when he was 21. He quickly took responsibility for the fire department museum and oversaw the construction of the model of the original fire station that now houses the refurbished *Tashtassuck No. 1* and the extensive fire department collection. (DHK.)

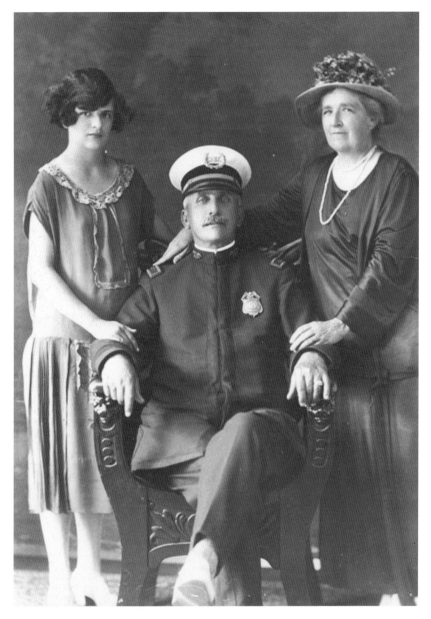

Charles Edward Hull
Prior to 1958, Jamestown had no police department, at least officially. Despite attempts to obtain authority from the state to create a police department, only constables with defined functions were specified in the town charter. The lack of official authority did not prevent the town council from appointing Hull as chief of police and designating special policemen to help him during the summer months. Under an ordinance passed in 1890, the chief's job was to "prevent the collection and disperse any disorderly crowd in such numbers as to obstruct the passage of peaceful persons through any public place, and . . . arrest without warrant and carry to the police station, any person who may be noisy and disorderly or intoxicated in any street or public place." In the winter, his duties included truant officer, enforcement of bird laws, and enforcement of laws against the spread of contagious diseases. Hull, pictured with his daughter Mabel and his wife, Alice, served as chief of police for 35 years.

James G. Pemantell

When Pemantell, who was born in Jamestown, joined the police force in 1963, the three full-time officers knew everyone on the island. Minor crimes were handled locally with the cooperation of island parents. During Pemantell's 30 years on the force, the town's population grew 120 percent, and as chief of police from 1974 to 1992, he oversaw the growth of the department to 12 full-time officers and the building of a new police station to house them. (DHK.)

Chester Green

Green followed Charles Hull as chief of police and served from 1931 to 1950. He took a personal approach to law enforcement and was usually to be found on foot at the East Ferry or on Narragansett Avenue. His hands-on approach was not always appreciated, and he was briefly suspended in 1947 following a complaint by Mary Tollefson (page 100) of discourteous behavior. (Courtesy of Norma Moll Walsh.)

Rev. Charles E. Preston

The Chapel of the Transfiguration, better known as the Movable Chapel, was the brain child of Preston, the rector at St. Matthew's Episcopal Church. He wanted to bring church services to the North End. The chapel near Carr Lane would serve the farmers in the winter and would move to Conanicut Park for vacationers in the summer. In April 1899, the completed chapel was moved, with great difficulty, by 10 yoke of oxen to a spot on East Shore Road. Six months later, Preston disappeared. He boarded a Fall River Line steamer to New York. In his cabin, officials found a note saying he had financial problems and asking that his family be notified. Suicide was assumed. However, not long after, Preston was spotted in the company of Emma Moss, a Jamestown schoolteacher whom he had known in Providence. Preston's wife divorced him. He married Emma and they had four children together. They were still married, and he was a Methodist minister when he died in Seattle in 1931 at the age of 71.

Mary Rosengarten

In 1904, the 1787 Jamestown windmill, unused since 1896, was quickly deteriorating. Mary Rosengarten, a summer visitor from Philadelphia, led the effort to save it. She collected more than $700 to buy the mill and oversaw its maintenance until the Jamestown Historical Society was founded in 1912. She is shown here (center) with her sons Clifford (on the floor) and Sam (on the porch rail), surrounded by unknown guests at Honeysuckle, the family's Jamestown cottage.

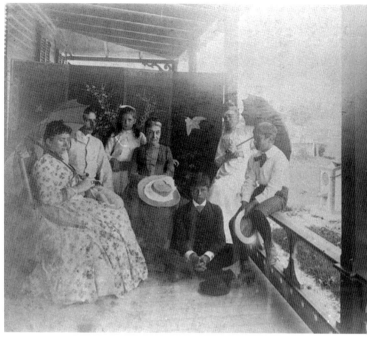

Heather and Donald Minto

Thomas Carr Watson Jr. bequeathed the 265-acre Watson family farm to Historic New England with the stipulation that it be operated as a working farm. The Mintos, the managers of the farm since 1980, continue Jamestown's long tradition of pastoral husbandry while using modern farming technology, such as temporary electric fencing powered with solar panels, to increase productivity. The beef and lamb sold at the farm are 100 percent grass fed. (DHK.)

William W. Miner, DO
In 1955, William and Mary Miner moved to Jamestown in part to escape the pollution of New Jersey oil refineries. Two years later, the Commerce Oil Refining Corporation announced that it intended to build an oil refinery on the island. Dr. Miner formed the Jamestown Protective Association and successfully fought the development. A similar environmental threat in the 1970s led him to found "Save the Bay," which works to protect all of Narragansett Bay. (Courtesy of Jane S. Miner.)

Mary Robinson Miner
After the Miners, who had been summer Jamestown residents since 1942, moved to the island full time, Mary Miner devoted herself to preserving the area's history. For 16 years she was curator of the Jamestown Museum, established in 1972 in an 1885 Jamestown primary school building. As Jamestown Historical Society's archivist until shortly before her death in 2005, she initiated new standards of care for the collection, especially of photographs and other archival material.

SERVICE IN OUR NATION'S WARS AND CONFLICTS IS REMEMBERED BY A GRATEFUL COMMUNITY

J. Christopher Powell
Preserving, protecting, and enjoying the natural beauty of Jamestown has kept Powell busy since he moved to the island in 1978. As the first chair of the conservation commission from 1983 to 2010, he was a persistent advocate, ensuring that environmental considerations were a major part of all land use decisions. He spearheaded efforts to preserve open space and farmland. He founded the Village Christmas Lighting and has been chief fool of the annual Fools' Rules Regatta since 1981. (Courtesy of the *Newport Daily News*.)

Betty L. Hubbard
Since she moved to Jamestown in 1985, landscape architect Hubbard, shown here in Veteran's Memorial Square, which she designed, has actively pursued the preservation of the visual environment of the town. On the planning commission (1991–2007), she urged review of development in the village, which ultimately led to a Vision Pattern Book and Design Guidelines for the area. She successfully advocated the addition of the Shoreby Hill Historic District to the National Register of Historic Places. (DHK.)

Edwin Wilmot Connelly

Art and historic preservation were Connelly's twin passions. He taught art history, studio art, and art appreciation for many years and was an active member of the Conanicut Island Art Association. A US Army veteran, Connelly worked for the Rhode Island Department of Veterans Affairs and was the state's first cemeteries director, documenting more than 2,000 historic burial grounds. Before he moved to Jamestown in 1985, much of his energy was expended in preserving the colonial and military history of Newport, including the founding of what is now the Fort Adams Trust. He chaired the commission that developed Jamestown's Veterans' Memorial Park at East Ferry, and he organized the Friends of the Conanicut Battery to reclaim the 1776 earthworks in the town's Conanicut Battery Historic Park. The park was rededicated in June 2002, shortly after Connelly's death.

CHAPTER NINE

Capturing the Beauty

Since the late 19th century, Jamestown has been a magnet for artists of all types, but especially those working in visual media. The first professional artist to move here was William Trost Richards (1833–1905), a marine artist from Philadelphia who built Graycliff in the Dumplings. The cottage is gone now, torn down about 1900 to make way for Fort Wetherilll. John Austin Sands Monks (1850–1917) visited and painted the agricultural scene. In the early 20th century, Francis X. West (1881–1971) opened his Red Elephant Studio on Cole Street. The professionals were quickly joined by amateur artists, such as Comdr. Charles Henry Davis 2nd (1845–1921), who retired to Jamestown in 1907 and painted marine scenes and local landscapes. As the 20th century progressed, the island attracted and bred its own artists. Catharine Morris Wright (1899–1988) knew the island from childhood. Constance Warren Armbrust (1907–2008) and Jeanne Barbaresi Bunkley (1918–2012) came for family. Evelyn Thistle Rhodes (1946–) and Jillian Barber (1946–) were attracted by the island's beauty and found their subjects in its people and scenery.

Other arts and crafts flourished also. Oliver Caswell (1836–1896) handcrafted beaded baskets in beautiful colors despite being blind and deaf. Harold Sherman (1903–1981) captured events in the town in photographs and on film. Writers stayed for only a short while before seeking more exciting places, except for Walter Leon Watson (1878–1975), who recorded the history of his family and of the town. Dramatics have a long history in Jamestown, from the skits and revues put on at the Grange and other organizations through the use of the island as a setting for movies, such as *Crash Dive* (1943) and *Moonrise Kingdom* (2012). Jane Sprague (1943–2003) formed Jamestown Theater, Inc., to create a home for the Jamestown Players. More recently, Patricia Vandal (1933–2010) and Mary Wright (1947–) founded the Jamestown Community Theatre to provide a dramatic outlet for the children of Jamestown and their families.

William Trost Richards

Richards, a Philadelphian, was the first artist of note to make his home in Jamestown. In 1881, he bought—or, according to some sources, was given—land in the Ocean Highlands development. If he was given the lot, the investment paid off for both him and the investors. A number of the artist's Philadelphia friends followed his lead and built large summer cottages in the area, and Narragansett Bay fed Richards's fascination with capturing ocean waves on canvas.

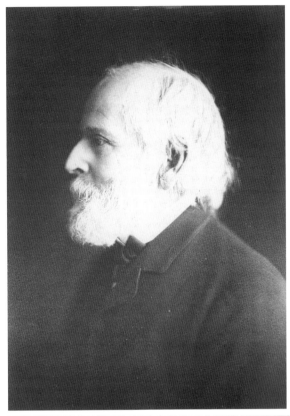

John Austin Sands Monks

Monks, on the other hand, was fascinated by sheep and built his career around picturing them in etchings, oils, and watercolors. The pastures of Jamestown gave him ample opportunity to practice his art. Although his visits were brief, his descendants still live on the island.

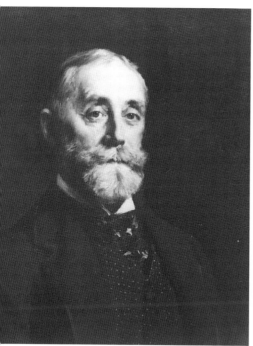

Commander Charles H. Davis 2nd
Davis, whose father was a rear admiral, attended the naval academy while it was in Newport during the Civil War. During his naval career, he collected and analyzed astronomical data for the US Naval Observatory. After his retirement, he began painting. Although best known for naval subjects, he painted many Jamestown scenes. (Courtesy of the Library of Congress, Prints & Photographs Division, Detroit Publishing Company Collection, LC-D416-70.)

Jeanne Barbaresi Bunkley
Bunkley was already an accomplished artist when she came to Jamestown with her husband, retired Rear Adm. Joel W. Bunkley, after World War II. In her two *Men of Jamestown* series, she captured over 100 local men in charcoal (see picture of Daniel Murray, page 111). She is best known for her portraits in oil, such as this self-portrait, entitled *Green Hat*. She started the Jamestown Christmas pageant in 1975 and was a founding member of the Conanicut Island Art Association.

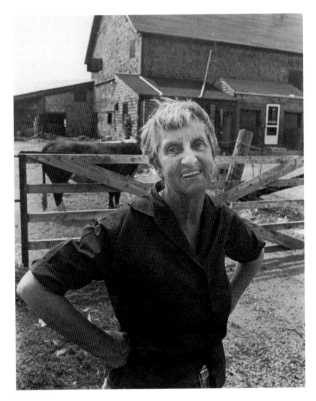

Catharine Morris Wright

Wright, a granddaughter of Joseph Wharton and the only child of Harrison S. Morris (page 61), was an artist, author, philanthropist, farmer, and guardian of nature. She first came to Jamestown before her first birthday and returned often, at first as a summer visitor at Horsehead and, after purchasing Fox Hill Farm in the late 1940s, as a resident. Wright was introduced to art and artists early in her life and in her teens attended the Philadelphia School of Design for Women. She painted most of her life. Her *Polishing Silver* was exhibited at the Art Institute of Chicago in 1936, her watercolor *String Quartet* is in the collection of the Pennsylvania Academy of the Fine Arts, and her oil portrait of her father hangs in the Newport Art Museum. Wright's love of nature showed in both her paintings and her philanthropy. The paintings often depicted the rocks, bushes, sky, and water of Conanicut Island. To help protect the environment, she established restrictions on development of her land with the Nature Conservancy and gave part of Fox Hill Farm to the Audubon Society for a nature preserve. She served on the boards of and made donations to many artistic and environmental organizations.

In 1936, Wright's interest in preserving the history of Jamestown led her to accept a charge from the Jamestown Town Council. Men working near West Ferry had dug up some human bones and artifacts. No one knew whose. To prevent further looting of the graves, the town bought the land and Wright was asked to take charge of the material recovered. The Wrights hired a professional anthropologist to excavate the site 30 years later. Catharine Wright donated the Sydney L. Wright room in the Jamestown Philomenian Library to display the artifacts—one dating from about 3000 BCE—that were unearthed.

Her poetry and essays appeared in magazines, including the *Atlantic Monthly* and the *Saturday Evening Post*, and she also published two books of poetry: *The Simple Nun* (1929) and *Seaweed, Their Pasture* (1946). She wrote an autobiography, *The Color of Life* (1957), collected her family history and reminiscences in *The Good Old Summer Time* (1963, with her husband Sydney), and wrote a biography of Mary Mapes Dodge (1979). She worked closely with Shirley Tiexiera Quattromani to publish a collection of interviews with Jamestown residents of Portuguese heritage called *History of the Portuguese of Conanicut Island, 1895–1980* (1980). (Courtesy of Harrison M. Wright.)

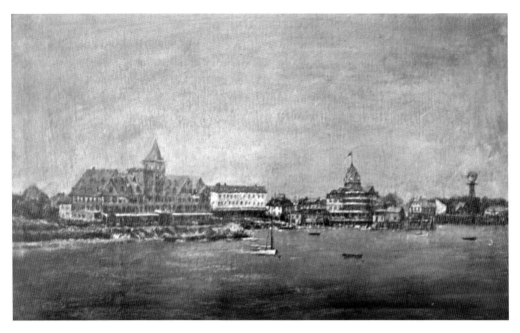

Francis X. West
West, born Francis Xavier Polusney, started painting after he ran away to join the Navy during the Spanish-American War. He settled in Jamestown in the first years of the 20th century and opened his Red Elephant Studio on Cole Street. He painted this oil of the Jamestown waterfront, called *Old Jamestown*, about 1940 from a black and white photograph of Jamestown in 1898. (DHK.)

Constance Warren Armbrust
Armbrust began studying art with Catharine Wright in 1948, soon after her 40th birthday. Over the next 60 years, she worked in oils, watercolor, and pen and ink. Her mugs and tiles with line-drawings of Jamestown scenes are still popular souvenir items. In 1976, Bank Newport commissioned the picture *Jamestown Waterfront, circa 1910*, which hangs in the Jamestown branch office. (Courtesy of Linda A. Warner.)

119

Jillian Barber
"My career as a ceramic sculptor began here," said Barber of this Beavertail carriage house, where she lived and worked from 1976 to 1982, before moving to West Ferry. Her passion is portraiture, and she has captured the likeness of many islanders in both clay masks and photography. An active gardener, Barber has created award-winning displays for the Quononoquott Garden Club. (Courtesy of Jillian Barber.)

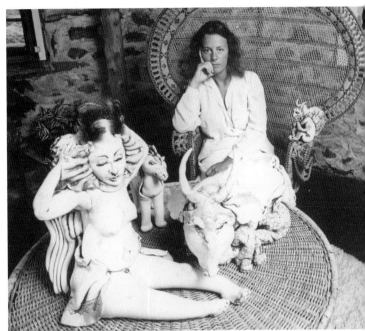

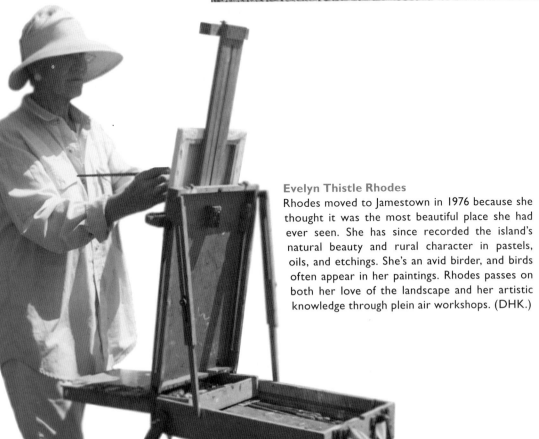

Evelyn Thistle Rhodes
Rhodes moved to Jamestown in 1976 because she thought it was the most beautiful place she had ever seen. She has since recorded the island's natural beauty and rural character in pastels, oils, and etchings. She's an avid birder, and birds often appear in her paintings. Rhodes passes on both her love of the landscape and her artistic knowledge through plein air workshops. (DHK.)

Oliver Caswell

Caswell, shown here with his teacher Laura Bridgman, was born in Jamestown in 1836 and lost his sight and hearing when he was two years old. Schooling for the blind and deaf was in its infancy, and for many years Caswell lived an isolated existence. When he was 14, he attracted the attention of Samuel Gridley Howe, who, in 1829, had founded the Perkins School for the Blind, the first school of its kind in the United States. Dr. Howe, with the help of Laura Bridgman, who was also deaf and blind, taught Caswell to speak and to read Braille. Caswell took great interest in meeting people. When Dom Pedro II, Emperor of Brazil, visited Newport in 1876, he sent for Caswell to visit him and Caswell evidently enjoyed the encounter. Caswell devoted his spare time to reading and to making small bead baskets, which he sold to help support himself. (Courtesy of Perkins School for the Blind and DHK.)

Harold A. Sherman
Sherman worked as quartermaster for the Jamestown & Newport Ferry Company and later the state ferry division for 45 years. His avocation was photography. He documented the building of the Jamestown Bridge in more than 150 photographs and photographed and filmed events in Jamestown from the 1920s through the 1940s.

Walter Leon Watson
Watson's mother was a Jamestown Carr, and his first historical work of note was "The House of Carr," a short history of the Carr family written in 1926 to celebrate the 150th anniversary of the building of the Carr Homestead. He continued to write papers and pamphlets about Jamestown; in 1949 he published *History of Jamestown on Conanicut Island in the State of Rhode Island*, the first complete history of Jamestown.

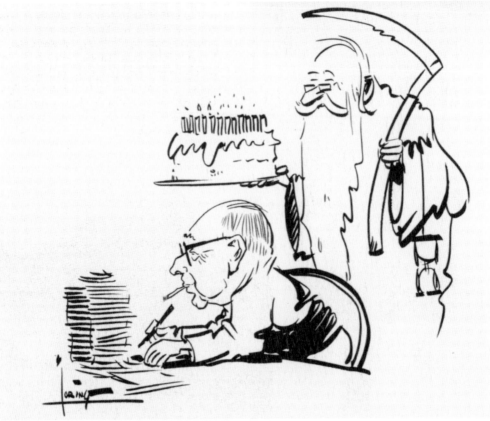

Evelyn Law

Law, who was reputed to be the highest kicker on Broadway, was a dancer with the Ziegfeld Follies and appeared in Broadway musical revues throughout the 1920s. A summer Jamestown resident, she was a friend of Sir Thomas Lipton, who between 1899 and 1930 challenged the American holders of the America's Cup five times with his yachts named *Shamrock* through *Shamrock V*.

Seth Morton Vose Sr.

Vose was a highly respected art dealer who discovered and brought to the United States paintings of the French Barbizon School. In 1881, he purchased Cajacet, the farmhouse built by Capt. Thomas Paine (page 14) about 1690 on the east shore at the North End. In front of the house are, from left to right, Vose, unidentified, Robert Churchill Vose, Nathaniel Morton Vose, Mary Lee Vose Warren, Hattie Edwards Vose Thompson, and Mary Branch Vose.

Jane Sprague
When Jamestown's only movie theater closed its doors at the end of the summer in 1977, nine Jamestown citizens, led by Jane and William Sprague, formed the not-for-profit Jamestown Theater, Inc. (JTI). The group bought the building in 1978 with the intention of renovating the deteriorated theater and using it for movies, plays, and other civic events. That December on the day of the mortgage closing, a wreath was hung on the building to celebrate. Seen here from left to right are Martha Leonard, JTI treasurer; Roy Dutra, seller of the building; Vincent Sisson from Savings Bank and Trust of Newport, the mortgage holder; Jane Sprague, JTI president; and Thomas Sisson, JTI secretary.

The Jamestown Players presented plays in the theater, and commercial films were shown starting in June 1980. But costs were high and attendance was not. In August 1982, with foreclosure imminent, the JTI admitted that the theater would never pay for itself and put it up for sale. It became the Bomes Theatre Mall.

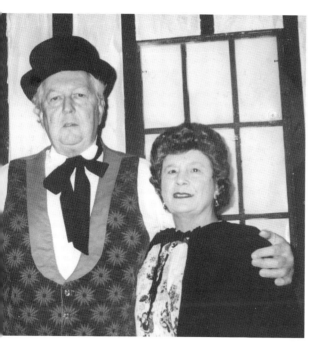

Patricia Miller Lyons Vandal and Mary Schachtel Wright
Almost eight years after Jamestown Theater, Inc., folded, Patricia Miller Lyons Vandal (with her husband, Maurice) and Mary Schachtel Wright joined forces to bring theater back to Jamestown. Vandal, who had grown up in Jamestown, was teaching music in the Jamestown schools when she met Wright, a teacher at the Rocky Hill School and a relative newcomer to Jamestown with professional experience on stage and in television. In 1990, they received $500 in startup money from the Jamestown Substance Abuse Prevention Task Force to stage a play with the youth of Jamestown. Both women wanted to strengthen the bonds between parents and their children and to foster relationships between children and other adults in the community. They insisted on a cast and crew that included both adults and children, all of whom lived in Jamestown. Vandal died in 2010. Wright continues to stage plays at the Jamestown Recreation Center that promote their philosophy of community involvement. (Courtesy of the Jamestown Community Theatre and DHK.)

INDEX